THE
Gardens
OF
Suzhou

Penn Studies in Landscape Architecture

John Dixon Hunt, Series Editor

This series is dedicated to the study and promotion of a wide variety of approaches to landscape architecture, with special emphasis on connections between theory and practice. It includes monographs on key topics in history and theory, descriptions of projects by both established and rising designers, translations of major foreign-language texts, anthologies of theoretical and historical writings on classic issues, and critical writing by members of the profession of landscape architecture.

The series was the recipient of the Award of Honor in Communications from the American Society of Landscape Architects, 2006.

THE
Gardens
OF
Suzhou

RON
HENDERSON

PENN

University of Pennsylvania Press
Philadelphia

Published with the aid of a grant from the Getty Foundation.

Published by University of Pennsylvania Press
Philadelphia, Pennsylvania 19104-4112

www.upenn.edu/pennpress

Printed in the United States of America on acid-free paper

10 9 8 7 6 5 4 3 2 1

Library of Congress Cataloging-in-Publication Data

Henderson, Ron.
 The gardens of Suzhou / Ron Henderson.
 p. cm. (Penn studies in landscape architecture)
 Includes bibliographical references and index.
 ISBN: 978-0-8122-2214-2 (alk. paper)
 1. Historical gardens—China—Suzhou (Jiangsu Sheng).
2. Gardens, Chinese—China—Suzhou (Jiangsu Sheng).
3. Landscape architecture—China—Suzhou (Jiangsu Sheng).
 SB466.C52 S8334 2013
 635.90951'136
 2012014202

The traditional character for garden, above, is a pictogram where one can imagine the outer square as a wall that encloses a garden. The radical at the top resembles the shape of a roof and may represent shelter or a pavilion. The middle radical depicts an inner bounded area, such as a pool or pond, which is commonly the center of a garden. The lower radical is shared with the character for a pomegranate tree, a symbol of fertility and thus, family. The garden, then, can be distilled as a bounded space that has, at its essence, three elements: shelter, water, and fruiting trees.

The simplified Chinese character for garden, above, implemented in Maoist reforms to increase literacy, loses these allusions although the enclosing wall remains. This is the Chinese character that is seen on maps and signs in contemporary Suzhou, but the traditional character may be seen in couplets, carved stones, and other ancient text in the Suzhou gardens.

The term for garden, *yuán*, is pronounced "you-ann," where "you" has an uninflected tone and "ann" has a rising second tone. As a small insight into the richness of Chinese language, *yuán* pronounced in this manner can also mean "circle," or "original." It is also the word for "money." These homophonic tropes are also the source of much Chinese humor.

CONTENTS

Preface *ix*

Visiting the Gardens *xi*

Map of Suzhou *xvi*

Introduction 1

Architecture in the Gardens of Suzhou 21

THE GARDENS OF SUZHOU

Humble Administrator's Garden (Zhuozheng Yuan) 33

Lingering Garden (Liu Yuan) 43

Lion Grove (Shizilin) 54

Surging Wave Pavilion (Canglang Ting) 60

Master of the Nets Garden (Wangshi Yuan) 65

Garden of Harmony (Yi Yuan) 78

The Couple's Garden (Ou Yuan) 81

The Garden of Cultivation (Yi Pu) 89

The Mountain Villa of Embracing Beauty
(Huanxiu Shanzhuang) 95

The Mountain Villa of Embracing Emerald
(Yongcui Shanzhuang) 101

Crane Garden (He Yuan) 108

Zigzag Garden (Qu Yuan) 111

Carefree Garden (Chang Yuan) 114

GARDENS NEAR SUZHOU

Garden of Retreat and Reflection (Tuisi Yuan), Tongli 119

Garden of the Peaceful Mind (Jichang Yuan), Wuxi 124

Garden of Peace and Comfort (Yu Yuan), Shanghai 130

Garden of Ancient Splendor (Guyi Yuan), Nanxiang 140

Other Gardens in Suzhou and Region 147

Comparative Plans 151

Plants in the Gardens of Suzhou 155

Stone in the Gardens of Suzhou 159

Glossary 163

Suggested Readings 165

Index 169

Acknowledgments 175

PREFACE

A friend once remarked that I was fortunate that I cannot read the Chinese language (apart from a few characters) when I visit the gardens of Suzhou. He said when he walks through the gardens, the preponderance of text continually tells him what he is supposed to see and experience. He envied my ability to walk through the spaces and understand them only for their proportion, material qualities, and spatial sequences because I could not understand the written inscriptions.

In this spirit, I have not included the name of every pavilion or scenic spot in the gardens. That information is available in more extensive texts in English, but it is cumbersome and distracting to read all the names and scenes in the garden and there is not space here to do justice to their derivation and scholarly allusions. Therefore, I mention the names of structures and scenes selectively.

Perhaps this is also my own way to shift the scholarship of these gardens away from their well-documented literary associations and symbolism toward an understanding based on their visual proportions, physical presence, spatial qualities, experiential sequences—and even their urban ecology—in an effort to extend their influence to the contemporary discourse on gardens and landscapes.

The gardens and their street addresses are listed with their names written in Chinese characters, with their Hanyu-Pinyin spelling, and with an

English translation. Fees for entrance into the gardens vary among sites and are subject to change so they have not been listed in this guide.

Translations are complicated by the nuanced meaning often embedded in the names of gardens, pavilions, and places in the gardens; I have provided the most commonly used names. For instance, the Zhuozheng Yuan, the Humble Administrator's Garden, may also be translated as the Garden of the Unsuccessful Politician.

All Chinese names are written in the traditional manner with the family name first.

Dates in Imperial China are designated by the year of reign of the emperor (e.g., twelfth year of the Emperor Qianlong). For convenience, dates are also provided in B.C.E. and C.E. years.

The garden plans are based upon the authoritative plans in Liu Dunzhen, *Chinese Classical Gardens of Suzhou.* My research assistants at Roger Williams University, Rhode Island School of Design, Tsinghua University, and The Pennsylvania State University drew the plans of the gardens, provided translations, and contributed in many ways: Frank Wierschalak, David Giuliano, Ryan Duval, Peter Bartash, Vivien Sin, Wu Kun, Elizabeth Hindman-Harvey, Demetrios Staurinos, Zhang Jingni, Xu Xiaoqing, Hsu Tingyun, Li Qiwen, Xu Shaonan Yang Xi, Mo Shan, Ni Xiaoyi, Zhao Qian, Zach Jones, and Lacey Goldberg.

All photographs are by the author except where noted.

VISITING THE GARDENS

A GUEST IN THE GARDEN

The gardens were built with the intent of providing pleasure to the family and invited guests. When you now visit the garden, do so as if you are an invited guest. You should enter the gate and proceed to the reception hall or main hall of the residence as this is where you would have been greeted by the owner. In almost every garden, a discreet passage from this hall leads out into the garden proper. Taking this path is an effective way to understand the spatial and experiential sequence of the gardens from a visitor's point of view.

GARDEN ETIQUETTE AND ATTIRE

The experience of these gardens by tourists is much different than the experiences of the families who lived here. It is impossible to savor the awakening quiet of a morning sunrise or the festive celebrations with friends and families that were routine for the residents of the gardens. Nevertheless, it is possible to see and stroll through the same spatial structure which has endured for generations.

The gardens are endangered by the crush of tourists, and it is my hope that timed entrance will soon regulate the flow of visitors to help preserve

the gardens and allow an enjoyable experience. Unfortunately, tour guides with amplified microphones can turn a tranquil visit into a frustrating one. On many occasions, I have gone through the gardens not at my own pace but trying to stay ahead of or fleeing the loud guides. I strongly hope that amplified microphones will soon be banned from these gardens.

There is a saying about Suzhou gardens, "Everything is green—except that little bit of red." This is good advice for attire in the gardens. Brightly colored clothing, although common among the former residents of these gardens, is a distraction now that they are filled with hundreds of visitors.

PAUSE AND OBSERVE

Listed with each garden are places to pause and observe. This is a plea to the garden visitor to stop for several minutes to allow the garden to "come to them." The places that I have included are intended to emphasize a historical point of view in the garden or are places of personal interest. These are merely suggestions and each visitor should discover his or her own meaningful places in the garden.

The inspiration for this component of the book comes from Chen Congzhou, the respected Chinese garden historian, who writes about two ways of experiencing the gardens in his book *On Chinese Gardens*:

> Chinese gardens may be divided into two kinds: "in-position viewing" i.e. lingering observation from fixed angles, and those for "in-motion viewing" i.e. moving observation from changing angles. This must be the first and foremost consideration before constructing a garden. The former means that there are more visual points of interest to appreciate from fixed angles, while the latter demands a longer "touring" vista.
>
> In small-scale gardens, the former type should be predominant and the latter secondary and the reverse should be the case in large-scale gardens. An example of the former type is Wangshi Yuan [Master of the Nets Garden], and of the latter Zhuozheng Yuan [Humble Administrator's Garden]. In Wangshi Yuan, you will discover many

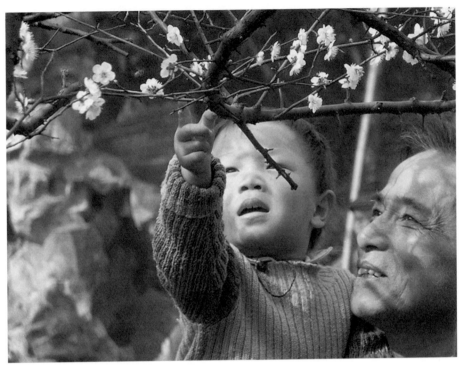

Figure 1. Close observation of blossoms at Guyi Yuan, Nanxiang.

buildings in which you would love to sit and linger awhile. You can make a tour of the pond, you can stand by the balustrade and count the swimming fish, or you can seat yourself in the pavilion to wait for the moon and greet the breeze. Outside the veranda the shadows of flowers move along the walls, and looking out through a window there are ridges and peaks like those in a painting. The serenity of the scene is enchanting. In Zhuozheng Yuan, paths wind around a pond, and long corridors draw visitors ahead. The pond looks like a miniature West Lake, where "gaily-decorated pleasure boats glide to and fro under the bridge at midday and visitors can catch glimpses of scented garments." The view changes with every step.

Below is a list of pause and observe topics along with the gardens in which I emphasize that particular element. In some instances, the topic

coincides with an aspect of a garden that is recognized as being exemplary. In other instances, I have paired topics with gardens based on my personal experience. For instance, I remember a particularly vivid sunset washing across the walls of the Crane Garden and have included that topic with that garden, although the sunset washing across the high white walls of Suzhou is certainly visible in many of the other gardens.

GARDENS

borrowed scenery	Garden of the Peaceful Mind (Jichang Yuan)
white walls	Crane Garden (He Yuan)
courtyards	Surging Wave Pavilion (Canglang Ting)
ponds	Garden of Retreat and Reflection (Tuisi Yuan)
streams	Garden of Peace and Comfort (Yu Yuan)
rock specimens	Lingering Garden (Liu Yuan)
rockeries	Mountain Villa of Secluded Beauty (Huanxiu Shanzhuang)
stone masonry	Mountain Villa of Embracing Emerald (Yongcui Shanzhuang)

ARCHITECTURE

halls	Master of the Nets Garden (Wangshi Yuan)
pavilions	Garden of Cultivation (Yi Pu)
garden corridors	Carefree Garden (Chang Yuan)
garden windows	Garden of Harmony (Yi Yuan)

PLANTS

trees	Lion Grove (Shizilin)
blossoms	Garden of Ancient Splendor (Guyi Yuan)

POETRY AND PAINTING

painting Humble Administrator's Garden
 (Zhuozheng Yuan)
poetic couplets Couple's Garden (Ou Yuan)
novels Zigzag Garden (Qu Yuan)

MAP OF SUZHOU

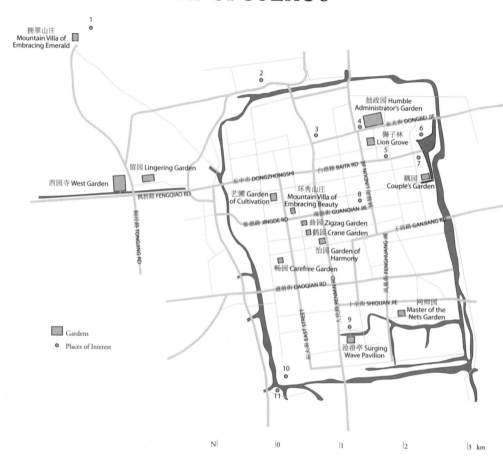

1. 云岩寺塔 Cloud Crag, or
 Tiger Hill, Pagoda
2. 火车站 Railway Station
3. 北寺塔 North Temple Pagoda
4. 苏州博物馆 Suzhou Museum
5. 半园 Half Garden

6. 动物园 Zoo
7. 东园 East Garden
8. 北寺塔 Temple of Mystery
9. 可园 Ke Garden
10. 瑞光塔 Auspicious Light Pagoda
11. 盘门桥 Pan Gate

Gardens discussed in the book are indicated by gray rectangles; other gardens and places of interest are listed in the numerical key.

INTRODUCTION

FIRST, THE LAND

The land—topography, waters, stones, vegetation, and climate—bestows the framework and materials of the great garden traditions of the world. Persian gardens amplify scarce water resources into fragrant courtyards. The Renaissance gardens of Italy negotiate the hills around Rome and Florence with terraces from which prospects are revealed, grottoes are embedded, and watercourses flow. The basins of water in French Renaissance gardens stretch across the level plains of central and southern France. The eighteenth-century English landscapes of rolling hills and shallow lakes were constructed on soft, chalky soils criss-crossed with gentle streams. The gardens of Kyoto benefit from a propitious climate for broadleaf evergreens, an abundance of moss spores, and a territory rich with both mountains and rivered plains.

Similarly, the gardens of Suzhou are born of their region. Suzhou is situated in the alluvial plain of the Yangtze River which spreads across eastern China from Zhejiang Province in the south to Shandong Province in the north. This great delta—a fecund land of water, rice, and fish—provides the foundation for one of the world's great garden traditions—one that has been cultivated for over 2,500 years. Mark Elvin, in his environmental history of China, reassures, "Here we are at last in the good part of China. . . . It is fifty leagues from south the north, and there

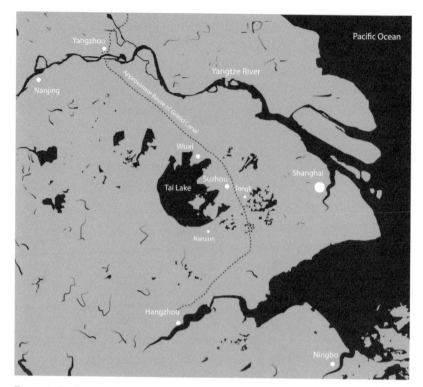

Figure 2. Suzhou sits between the Yangtze River delta to the north, Hangzhou Bay to the south, Tai Lake to the west, and the Pacific Ocean to the east. This land of shallow, slow-moving waters and temperate climate establishes the framework of natural history from which the garden traditions of Suzhou grew.

is no question of mountains. This landscape is as level as a mirror all the way to the horizon."

Twenty thousand years ago, the area that is now Suzhou was a shallow sea where coral flourished. Rivers brought sediment from the western loess plateaus and deposited it on the ancient shores while the ocean slowly receded—water giving way to low-lying flat land. Today, Suzhou is still only about thirty-five miles, or sixty kilometers, inland from where the Yangtze River meets the Pacific Ocean.

The oceanic coral metamorphosed into limestone that was subsequently carved by the rivers that stream across the plain. This water-carved formation—the porous limestone from Tai Hu, or Tai Lake, would become one of the most prized materials for the construction of the gardens of Suzhou

and throughout China. These limestone rocks are preferred for the piled rockeries and specimen stones that are unique features of the Chinese classical garden. It is the masculinity of these stone rockeries contrasting with the limpid shallow waters of the region that establish the framework of mountains and water, or *shanshui*, for the gardens of Suzhou.

GARDENS IN CHINA

The earliest description of a garden in China is contained in the Book of Songs, the fourth-century B.C. collection that is regarded as the first book of Chinese literature. In it, a wall encloses a residence as well as specimens of useful trees such as mulberry and willow. The description closely resembles the Chinese character for garden.

In a poem dating from about the same time and later compiled in the Songs of Chu, an imaginary garden is described in a passage where the soul of a dying king is being coaxed back to his body by describing the place where he will find a princess: a garden where linked corridors capture the aroma of orchids, streams meander past halls, pavilions rise above palace roofs, balustrades support the king to lean over and look into lotus-filled ponds, and a tall mountain provides a prospect to look down on the garden and out to distant hills.

THREE TYPES OF GARDENS

There are three types of traditional gardens in China: the monastic courtyards, the imperial gardens and hunting grounds, and the scholar gardens such as those in Suzhou. The monastic courtyards are distributed throughout hills and mountains where the Buddhist and Daoist doctrines establish the idea of hermitage or retreat. The imperial gardens and hunting grounds that remain are in and around Beijing (including the Mountain Resort in Chengde), although evidence remains of them in many of the cities that have, over time, served as capitals of the Middle Kingdom. Last, the private gardens that are the subject of this book are largely concentrated in

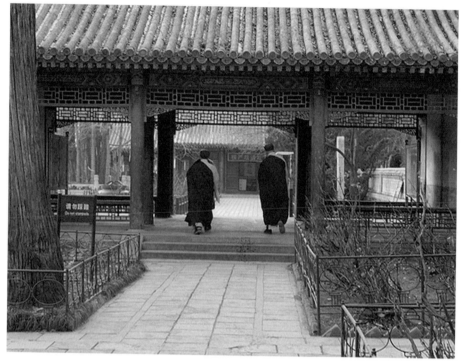

Figure 3. Courtyard Garden at Tanzhe Temple outside Beijing, where the monks have tended an ancient ginkgo tree for 1,400 years. (Photo by Brendan Riley.)

the area just south of the Yangtze River in eastern China in cities such as Suzhou, Hangzhou, Shanghai, Wuxi, Nanjing, and Yangzhou, which have been prosperous centers of commerce and education for centuries.

Monastic Courtyards

At Tanzhe Temple in the western hills of Beijing, the monks have tended an ancient ginkgo tree for 1,400 years. In courtyards such as this, the ginkgo—one of the oldest species of plants—was cultivated at the brink of its extinction. Other trees such as pines and horsechestnuts, known as the Buddha tree because it is the genus under which the Buddha presumably achieved enlightenment, are also common in the courtyards.

Both Daoist and Buddhist temples maintain similar four-sided courtyards, the pervasive architectural building block of China. From rural farmhouses to the imperial residences, the enclosure of a plot of land with a

wall and the organization of south-facing buildings around a courtyard has been the module of human dwelling.

In the monastic courtyards, the routine tending of plants, such as the ginkgo or the peony, has embodied a relationship between human and natural cultures. In this case, the monks of Chinese temples share a compulsion with greater humankind. As Robert Pogue Harrison proposes, "If life is indeed a subset of gardening, rather than the other way around, then there is every reason to believe that if humankind has to entrust its future to anyone, it should entrust it to the gardener, or to those who, like the gardener, invest themselves in a future of which they will in part be the authors, though they will not be around to witness its full unfolding."

Imperial Gardens and Hunting Grounds

The earliest imperial gardens were hunting grounds, and the Mountain Retreat in Chengde north of Beijing remains as physical testament to their scale and refinement. In Beijing, the Nanyuan District, south of the formerly walled capital, is named for the South (Nan) Garden (Yuan), the imperial hunting ground where Pere David's deer and other game were collected for imperial hunts. These Chinese imperial hunting grounds parallel the hunting grounds of Europe and Middle Asia where kings and royalty would enter into the wilder landscape of plains or forests for pleasure and camaraderie.

The imperial gardens were built as large winter or summer palaces just outside the city. The Garden of Perfect Brightness (Yuanming Yuan) and Summer Palace (Yihe Yuan), gardens in the northwest suburbs of Beijing, are such imperial gardens. The Garden of Perfect Brightness, which was destroyed in the nineteenth century, effectively served as the seat of the Qing Dynasty emperors for half of each year—and was perhaps more of a favored home than the Forbidden City. The gardens of the Garden of Perfect Brightness, like most gardens in China, are gathered around central bodies of water.

Private Gardens

Unlike the imperial gardens, the private gardens are urban residences where the gardens and living quarters are retreats within the city. In part,

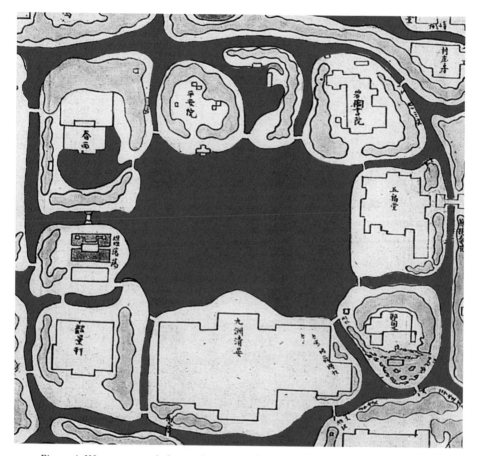

Figure 4. Water commonly lies at the center of classical Chinese gardens. An array of nine islands surround a square-shaped pond at Jiuzhou, a precinct of the Garden of Perfect Brightness, the imperial garden in Beijing.

their potency lies in the abrupt transition from the bustling life of the city into the quiet and carefully cultivated—albeit lively and domestic— garden. Residents of the garden, in addition to the primary family, might include parents, visiting or wayward relatives and friends, mistresses, and an array of domestic help. The life of the garden would have a variety of impressions and meaning depending on the group to which you belong. As joyous and idealized as we may imagine the gardens (they were often full of music and celebrations), they were also full of family intrigue and misadventure.

AGRICULTURE IN THE GARDEN

To these three garden types, as with landscape traditions in most cultures, one must add agricultural practices. China is remarkable for the enduring and pervasive cultivation of land in all corners of the country. The Chinese word *fan* designates not only food or a meal in its' general sense, but it is also the word for rice. In the language, rice is food; the meal. For millennia, the cultivation of this staple crop has created enduringly beautiful expressions of the farmer's art—vertiginous terraces clinging to the contours of hillsides and ingenious earthen weirs that deploy water across shallow alluvial plains. These are the techniques that became essential to the construction of the Suzhou gardens—stacking stones and diverting water.

Orchards figure prominently in the Chinese cultural imagination, especially the peach blossom. In his prose poem "Records on the Land of Peach Blossoms," Tao Yuanming (365–427) describes a fisherman who follows an orchard of peach blossoms along a creek to the edge of a cliff. In the cliff, he spies an opening—a cave—into which he enters and discovers a peaceful and fertile society. This Land of Peach Blossoms is the most enduring of Chinese models of idealized landscapes and utopian societies.

In the Ming Dynasty, the imperial families of Beijing began building gardens in the fecund territory just northwest of the capital city. These were didactic gardens intended to re-introduce agriculture, and by example agricultural policy, in the new regime. The scholar gardeners of Suzhou are often described as constructing urban places for retreat and as a place for aesthetic pursuits that epitomize a Daoist ideal, yet, as Craig Clunas has pointed out, the owners were also situating themselves in a political practice as highly educated gentlemen farmers—a parochial reinterpretation of the Beijing emperors.

EARLY GARDENS OF SUZHOU

Suzhou was founded in 514 B.C.E. in the Spring and Autumn Period when He Lu ascended the throne and built a city twenty-three kilometers in circumference that was protected by eight land gates and eight water gates.

Figure 5. The entrance to Surging Wave Pavilion, the garden with the longest history in Suzhou, is at the end of a bridge that crosses one of Suzhou's many canals.

Panmen (Pan Gate), in the city's southwest corner, is preserved from this period. The first recorded gardens in the city were imperial gardens built by He Lu, whose Gesu Terrace was built southwest of Suzhou, and by his son, Fu Chai, who built the Guanwa Palace. Private gardens first appeared in the Eastern Han Dynasty with gardens such as Zuo's Garden, built by the senior official Zuo Rong.

PROSPERITY BORN OF THE
YANGTZE RIVER AND GRAND CANAL

The early history of China is marked by west to east transportation along the Silk Road and the great rivers. Xi'an, an early capital, is far inland from the commercial, trade, and political centers of contemporary China. The

construction of the Grand Canal strongly influenced the change that altered the "flow" of China forever and linked Hangzhou, Suzhou, Yangzhou, and Beijing, among others. These cities remain, almost thirteen centuries later, the most prosperous in China. Suzhou lies at the strategic intersection of these two systems—the east to west Yangtze River and the north to south Grand Canal. Coupled with fecund agriculture and the development of silk culture in the region, Suzhou has remained a commercially successful, and thus, wealthy, city for much of the past millennium. This prosperity contributed to the rise of a class of citizens interested in making gardens.

THE GARDENS OF SUZHOU THROUGH HISTORY

The history of the design and construction of gardens of Suzhou—as with many sites in China—is complex. Gardens were constructed, bought, sold, left to degrade, appended to, and modified in many ways over centuries. The golden age of the Suzhou gardens was from the sixteenth to eighteenth centuries during the Ming and Qing dynasties, but most of the gardens of Suzhou were significantly destroyed by the end of the 1940s following invasion by foreign nations, the internal Taiping Rebellion, the fall of the Qing Dynasty, and the wars and revolutions of the twentieth century. Most of the gardens and pavilions are, thus, recent restorations or reconstructions. Yet the desire to restore the gardens of Suzhou affirms that gardens are one of the highest cultural accomplishments of humankind, and they persist in both the imagination and in material culture despite their neglect or destruction.

The Song Dynasty
Surging Wave Pavilion, the garden with the longest history in Suzhou, was first built during the reign of Emperor Qingli (1041–1049) of the Northern Song by Sun Shunqing. It exemplifies the fleeting nature of gardens for, although it maintains the general layout from the Song Dynasty garden that was built on the site of an earlier residence, it has been repeatedly destroyed and rebuilt. It was fully destroyed in the nineteenth-

century Taiping Rebellion and rebuilt in 1927 as part of the adjacent art college.

The Master of the Nets Garden was first built as the Ten-Thousand-Volume Hall in 1440 by Shi Zhengzhi. It was abandoned after his death and was rebuilt in 1770. The current garden is largely the result of a fine restoration in the 1940s by the He family.

The Yuan Dynasty

Among the characteristics of the Yuan Dynasty, founded by Kublai Khan, was a cultural polyglot that provided freedom for various religions—including the flourishing of Buddhism in China. It was in this context that disciples of the Buddhist monk Zhongfeng built the monastery Shizilin, the Lion Grove, which subsequently became a private garden.

The Ming Dynasty

In the Ming Dynasty, the Han Chinese regained power and a flowering of culture ensued that led to the creation of elegant painting, poetry, furniture, calligraphy, architecture, and gardens. There were more than 270 gardens in Suzhou during this period.

Gardens which were founded in the Ming Dynasty and still survive include the Humble Administrator's Garden, Garden of Cultivation, and Lingering Garden. The Garden of the Peaceful Mind in Wuxi, the Garden of Peace and Harmony in Shanghai, and the Garden of Ancient Splendor in Nanxiang also date from this period.

The Qing Dynasty

Among the 130 gardens that were founded in Suzhou in the Qing Dynasty, those that survive include: the Mountain Villa of Embracing Beauty, the Couple's Garden, Garden of Harmony, Zigzag Garden (former residence of Yu Yue), Mountain Villa of Embracing Emerald, Crane Garden, and Carefree Garden. The Garden of Retreat and Reflection in Tongli also dates from late in this period.

Contemporary Suzhou Gardens

By the middle of the twentieth century, domestic and foreign unrest had wracked China. In a period of more than one hundred years, much of the

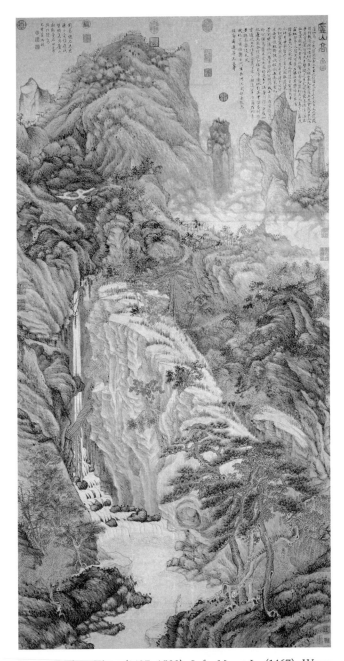

Figure 6. Shen Zhou (1427–1509), *Lofty Mount Lu* (1467). Water spills into a rocky waterfall and into a calm stream. A trail winds up the left side, across a bridge, and leads to a small hermitage tucked behind a peak in the center right. National Palace Museum, Taiwan, Republic of China.

knowledge and skill of building the gardens was lost. Chinese landscape architects and garden designers continue to struggle with the lost construction skills and extension of the ideas embodied in these gardens. Contemporary Chinese garden design is in a crisis of poorly built reproduction gardens on a grand scale.

Some recent gardens, such as the ones at the Suzhou Museum, point to possible directions. However, the central garden is poorly scaled, among other shortcomings. The bamboo courtyard off of one of the north galleries, however, is exquisite. Suzhou remains a center of garden scholarship and talent with many elegant private gardens constructed in recent years which provide promise for the continued vitality of Suzhou, a modern city of four million people, as one of the world's great places for gardens.

LANDSCAPE PAINTING

Chinese landscape painting has expressed the place of humans within the world for centuries. By the late Tang Dynasty (618–907), landscapes had emerged as their own genre and have remained a central subject of painting in China since. The Tang paintings depict vast mountains and watersheds with sparse evidence of human inhabitation. These mountain-water, or *shanshui*, landscapes depict places of retreat for men in times of political upheaval or personal quests for understanding and enlightenment.

The landscape painting of the ensuing Song Dynasty (960–1279) reflected the more strict Confucian social order initiated during this time. The image of the private retreat, or hermitage, emerged as well-educated—but disgraced or retired—officials retreated into poetry and an expressive painting style that shared its emotional force with calligraphy.

The Yuan Dynasty (1279–1368), begun under Mongol ruler Kublai Khan, expelled the educated Chinese officials from service. Many retreated into garden residences where they continued, with their friends and colleagues, to practice the life of the courtly scholar. The model of the domestic retreat flourished in this short, but dynamic, period. From these urban retreats, the scholars produced paintings that began to represent

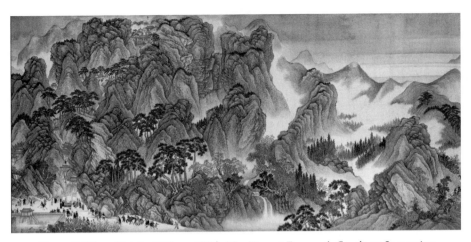

Figure 7. Wang Hui (c. 1632–c. 1717), The Kangxi Emperor's Southern Inspection Tour, Scroll Three: Ji'nan to Mount Tai (Kangxi nanxun, juan san: Ji'nan zhi Taishan). Qing dynasty, datable to 1698. Handscroll; ink and color on silk. 26¾ in. × 45 ft. 8¾ in. Detail. Purchase, the Dillon Fund Gift, 1979. The Metropolitan Museum of Art, New York. Image copyright © The Metropolitan Museum of Art / Art Resource, NY.

idealized versions of a cultivated society where thatched cottages and fishermen became metaphors for a humble life.

When Han rule was restored under the Ming Dynasty, (1368–1644), there was a return in the imperial courts to Confucian orderliness in all aspects of society, including painting that represented a benevolent, well-governed, hierarchical government. However, the personal expression of the scholar-painter endured, especially as officials suffered political setbacks or retired from imperial appointments to return to their native cities and towns. Among the places that had sent many scholars to the imperial court, and was therefore a place of retreat for retired officials, was Suzhou.

When China came under the rule of the Manchu Qing Dynasty (1644–1912), many scholars lived in self-enforced retirement. Lacking court access to the vast artistic holdings of the government, these scholar-painters were forced away from the common process of copying masterworks. The result was an emphasis on local scenes or landscapes and a wide ranging invention of subject matter. In this period, the gardens influenced the subject of paintings where previously gardens were influenced by the paintings.

In contemporary China, the landscape genre remains central to the emergence of international Chinese artists. Among them is the expatriate Zhang Daqian (1899–1983) who, with his brother Zhang Shanzi, lived for a period of time in Suzhou's Master of the Nets Garden, where the current Peony Pavilion served as their studio.

SPACE IN THE GARDENS OF SUZHOU

The gardens of Suzhou neither recede from the visitor nor spread out in repose. The elements of the gardens confront the visitor—pushing rocks, trees, and walls into the foreground—compressing and compacting space—is if great hands gathered a mountainous territory with rocks, forests, and streams, then squeezed it tightly—and ever more tightly—until the entire region would fit into a small city garden.

Peter Jacobs, the Canadian landscape architect and educator, remarked to me that his photographs of the gardens of Suzhou were predominantly oriented vertically—in contrast with his photographs of most gardens elsewhere in the world, which were oriented horizontally in so-called landscape format. The modern instrumentality of the camera assists us in interpreting the movement of our gaze rising from shallow waters, up stream banks, and high to distant peaks. A similar analysis is often undertaken in the study of Chinese landscape paintings, many of which are also oriented vertically. Common among many is the division of the painting into three zones: at the bottom, a foreground of water; at the center, a small sign of human habitation in a wide landscape; and at the top, the craggy outlines of folded mountains. The viewer's gaze, as with the observation of the gardens, travels up and down these paintings.

THE QUESTION OF AUTHENTICITY AND HISTORY

The Chinese garden historian Chen Congzhou, in his collected essays, *On Chinese Gardens*, remarks that the Garden of Harmony "was four times renovated to attain its perfection." Most of the current gardens, as I have

pointed out, actually date from recent, exhaustive renovations. The Garden of the Peaceful Mind, in Wuxi, has probably survived with greater "authenticity" than any other. The gardens have all undergone changes of ownership and maintenance, and one should, with few exceptions, understand that what is seen today is a physical palimpsest of repairs, renovations, and extensions of the gardens. As Maggie Keswick declared, "Chinese history is littered with the corpses of gardens."

For some, the fact that the gardens are reconstructions is problematic in a current period sometimes described as the "age of reproduction." Yet, as Pierre Ryckmans cautions, "The Chinese past is both spiritually active and physically invisible."

> The non-Chinese attitude—from ancient Egypt to the modern West—is essentially an active, aggressive attempt to challenge and overcome the erosion of time. Its ambition is to build for all eternity by adopting the strongest possible materials and using techniques that will ensure maximum resilience. Yet, by doing this, the builders are merely postponing their ineluctable defeat. The Chinese, on the contrary, have realised that—in Segalen's words—"nothing immobile can escape the hungry teeth of the ages." Thus, the Chinese constructors yielded to the onrush of time, the better to deflect it.

REPOSITORIES OF HISTORY AND CULTURE

The gardens are also repositories of cultural artifacts and traditions. The names of halls and gardens allude to—and remind knowledgeable visitors of—ancient poems and legends. The inscribed horizontal boards above doorways and above the honored position inside the halls perform similar roles, as do the paired vertical couplets mounted on the columns of the halls. These are not only renowned for the sentiments of the words but also for the spirit and skill of the calligraphy—sometimes at the hands of an important figure such as the Emperor Qianlong, who composed many such artifacts.

Stone inscriptions, doorway carvings, and steles also contain rich liter-

ary allusions or propagate the philosophical views of Confucian, Buddhist, or Daoist schools of thought and are intended to trigger lofty thoughts or enhance the potency of places in the garden.

Ancient scroll tables (whose ends turn up to prevent scrolls from rolling off), upright chairs, blue and white porcelain, carved inkstones, and other furnishings of the scholar's residence are also preserved in the gardens.

ANCIENT TEXTS

Three books provide special insight into the Chinese garden. *The Craft of Gardens*, or *Yuan Ye*, was compiled in three volumes by Tongli native Ji Cheng at the end of the Ming Dynasty. *The Story of the Stone*, the Ming Dynasty novel with vivid depictions of life in the gardens, was inspired, in part, by the boyhood experiences of the primary author, Cao Xueqin, in the Humble Administrator's Garden. *The Manual of the Mustard Seed Garden*, first published in 1679, codifies the art of landscape painting and includes a collection of exemplary landscape paintings.

GARDEN CONSTRUCTION

The designers of the gardens of Suzhou are largely anonymous. A myriad of skilled craftsmen worked within extended cultural traditions to produce them. Many gardens are attributed, instead, to poets or painters who inspired the gardens or scenes within them. There are a few notable garden makers—such as Ge Yuliang, who made the centerpiece rockery at the Mountain Villa of Embracing Beauty—yet most of the garden makers are obscured in history.

The revitalization of the construction trades and craftsmen in all aspects of Chinese gardens, landscapes, and architecture after the fall of the Qing Dynasty continues to be an imperative. For more than a century, these skills have atrophied, and the passing of expertise from generation to generation has been abruptly severed. Today, the quality and material integrity of construction in many fields is largely artless, and the successful emergence of

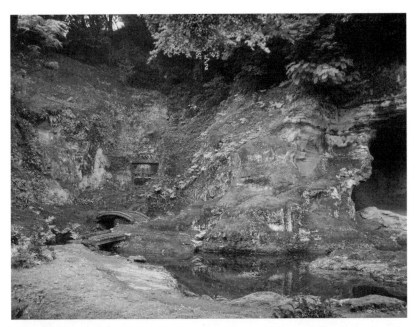

Figure 8. Zuisen-ji, a garden by the Zen Buddhist monk Muso Soseki, bridges the traditions that underlie essential aspects of the gardens of China and Japan. A veranda looks out onto a rock cliff with a pond, two bridges, and a man-made cave at its base.

contemporary material culture will require the education of new skilled craftsmen.

GARDENS OF CHINA AND JAPAN

Two of the world's great garden traditions are separated by a narrow sea, yet the experience of the gardens differ radically. The iconic Chinese garden is full of fanciful scenes that are entered with anticipation of joyful camaraderie and romantic trysts. The iconic Japanese garden, such as Ryoan-ji where fifteen stones are arrayed across a raked gravel surface, is a space separated from the observer and marked by silent personal introspection.

In Japan, the monastic gardens are perhaps the most celebrated, and therein rests a key distinction between the traditions. In China, design of monastic gardens clung to the pervasive model of four-sided courtyards

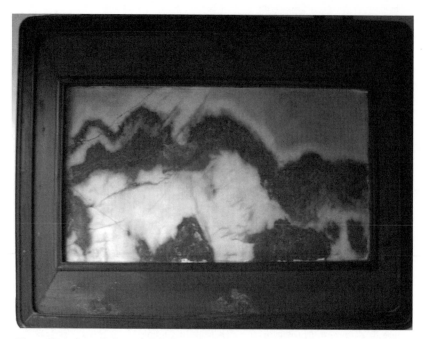

Figure 9. A framed slice of rock from the Lingering Garden portrays a mountainous landscape.

enhanced by trees, shrubs, and flowers, many of which are embedded with metaphorical meaning or illustrious associations, such as the ginkgo, peach, and peony. In Japan, the material articulation and spatial organization of monastic gardens aspired to what the twentieth-century Japanese architect Shinohara Kazuo describes as the removal of all external associations—a search for the essence of things.

Chinese garden ideas were carried in the minds of Buddhist monks who travelled between China and Japan. Among them was Muso Soseki (1275–1351), who, with others, reopened trade between China and Japan during the Yuan Dynasty. He was first among the Buddhist garden-making monks of Japan and several Zen Buddhist gardens attributed to him survive.

Of particular interest among his gardens is Zuisen-ji, in the temple-rich city of Kamakura, south of Tokyo, which was built at about the same time as the Lion Grove in Suzhou. The powerful juxtaposition of rocks and

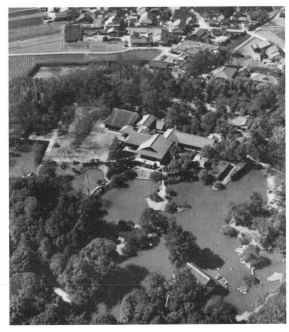

Figures 10 and 11. Both the Humble Administrator's Garden (1513–1529) in Suzhou (above) and Katsura Rikyu (c. 1620) in Kyoto (left) are strolling gardens organized around ponds. Comparing these two gardens, along with the English garden at Stourhead (1741–1765) which is similarly gathered around a body of water, reveals that paths circumnavigating a body of water is a fundamental typology around which gardens can be organized. Katsura aerial image from Maria Lluisa Borras, *Daitokuji Katsura* (Barcelona: Ediciones Poligrafa, 1970), photo by Yukio Futagawa.

water in this garden gives enduring evidence of the exchange of ideas between China and Japan. As one sits on the veranda of the temple, one's gaze rises from a shallow pond at the bottom, to an excavated hermit cave in the middle, to the rocky cliff that consumes the upper reaches of the view—all advancing toward the viewer, obscuring distinctions between near and far, texture and object, or human and natural.

Comparing the Humble Administrator's Garden in Suzhou and the stroll garden at Katsura in Kyoto, both private gardens of literate society, reveal more spatial, material, and experiential similarities than differences. These two garden cultures continue to find human agency in the cultivation of space.

Both gardens are organized with a pond in the center around which one would walk or stroll. Bridges and pavilions are integrated into the garden sequence and structure.

Two of Asia's most important novels—*The Tale of Genji* (arguably the oldest novel in the world) and *The Story of the Stone*, also known as *The Dream of Red Mansions* (one of China's great novels)—are set in garden residences not unlike Katsura and the Humble Administrator's Garden. Their descriptions of life in the gardens bear similarities in the events and daily life of the gardens—as well as the courtly and familial intrigue that permeated them. However, the compartmentalization of garden rooms with high white walls that are punched through with round gates and carved windows in the Humble Administrator's Garden is contrasted with the detached configuration of pavilions and garden spaces at Katsura. Architectural space in the Humble Administrator's Garden is bounded by masonry walls, while at Katsura, the palace sits isolated in gardens that are enclosed by forest. As a result, the gardens of the Humble Administrator's Garden are enriched by light reflecting off the walls and a strong contrast between light and shadow. At Katsura, the light is absorbed and diffused into evenly lit interiors enclosed by paper walls and absorbed on moss-covered ground.

ARCHITECTURE IN
THE GARDENS OF SUZHOU

with Jia Jun 贾珺

A potent contrast exists between the orderly sequence of four-square courtyards fronted by rectangular halls of the residential precinct and the confounding variety of pavilions, rockeries, ponds, corridors, and courtyards in the gardens. The residential halls and courtyards reveal a formal, Confucian hierarchy of relationships while the gardens express, it is often suggested, a Daoist flexibility. The scholar-officials who typically built the gardens led lives that similarly negotiated between these two philosophical poles and the vitality of the gardens of Suzhou is often amplified by this contrast.

FIVE BAYS, THREE BAYS, ONE BAY

The importance of each building is directly related to its size, or more important, to the number of structural bays across the front. The Hall of Supreme Harmony in the Forbidden City has eleven bays, the most of any classical building in China, which gives testament to its preeminent position in the national hierarchy. Few domestic buildings would have more than five bays, which is the common number for the largest halls in the Suzhou gardens, including the largest one, the Nanmu Hall in the Lingering Garden.

Three-bay buildings are usually studios, libraries, or secondary halls.

The diversity of one-bay pavilions, half-pavilions, and porches gives credence to the inventiveness possible even when working within a thousand-year-old cultural tradition.

RECEPTION HALLS

At the Master of the Nets Garden, three halls face courtyards in the southeast corner of the property. Visitors approach the garden along a public alley but at the front gate they arrive into an elegantly proportioned fore-

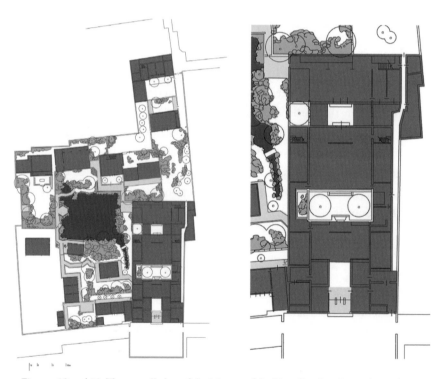

Figures 12 and 13. The overall plan of the Master of the Nets Garden shows the various building types that are integrated into the garden. At the southeast (lower right) is the residential quarters gathered around three courtyards. In the northwest (upper left), a study overlooks a private courtyard. In the northeast (upper right), domestic quarters are entered directly from a separate northern entry. Around the garden pond are an array of large halls, pavilions, half pavilions, studies, and linked corridors. A detail plan of the entry halls and courtyards of the residential quarters is shown at right.

court of simple white walls that is connected to a hall for sedan chairs—essentially a well-appointed garage. In the inner courtyard, there is often an elaborate gate, such as at the Master of the Nets. This gate, however, does not address the arriving visitor, but rather is oriented inward, and therefore addresses the departing visitor or those seated in the reception hall facing it across the courtyard.

In the reception hall, formalized social rituals play out in accordance with Confucian doctrine. Acquaintances or officials would not be invited further into the residence. Close friends and family, however, could be directed from the reception hall into the garden, often through a direct, but concealed, connection.

These halls, often the largest in the residence, inevitably face south and open out onto the entry courtyard with a wall of small carved wooden doors that often depict birds and flowers, whose allusion somehow compensates for the inert stone courtyards. Overhead, above a group of chairs and tables of substantial formality, is commonly a carved calligraphic tablet flanked by carved bamboo couplets on the wooden posts of the hall. These tablets and couplets announce the idealism of the garden owner, such as the "Master of the Nets" or the "Humble Administrator."

Behind this sitting group is a wall that conceals the door on the north side of the hall. To continue to the next, and increasingly private, courtyard, one slips around either end of the wall, which also blocks cold and damp winds, and advances into the next courtyard. This process repeats itself, and in some large residences involves as many as five or six courtyards.

TWO-STORY HALLS

It is common that the second or third courtyard would include a two-story building, the upper floor of which is used for sleeping. Carved doors and windows open to the north and south to provide fine cross-ventilation. Stairs may be internal to the building but are often built as external rockery piles with secluded steps, such as at the West Tower in the Lingering Garden or at the Nanmu Hall at the Mountain Resort in Chengde.

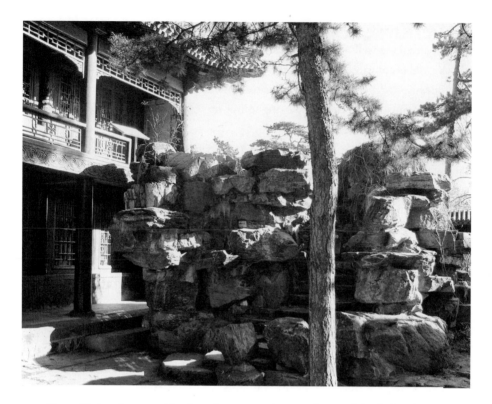

Figure 14. A rockery provides the only access to the second story of this hall at the Imperial Summer Resort in Chengde, north of Beijing. There is no internal staircase connecting the first and second floors. Similar staircase rockeries can be found in Suzhou gardens. The ground floors of many halls and pavilions do not have steps but a shallow rock formation laid in repose in front of the center bay upon which one clambers up to the floor level.

LIBRARIES AND STUDIES

The Hall of Ten Thousand Volumes in the Master of the Nets Garden pays homage to the original garden, which was built around a former study of the same name. The hall, just north of the three formal courtyards, makes a subtle shift in orientation that frees it from their geometrical order. Halls such as this were used for studying, reading, or teaching and were outfitted with tall tables with turned-up ends for reading scrolls, desks with brushes and ink stones, and shelves for stitch-bound books.

PAVILIONS

Strategically situated throughout the gardens are small pavilions. Some are perched atop the highest point in the garden to allow views over the city, canals, or countryside. Others lie close to the surface of the water from which one can watch the fish swim. The Ming era pavilion in the Garden of Cultivation has a particularly unique roof structure. The pavilion, "With Whom Shall I Sit," located just inside the western section of the Humble Administrator's Garden, is celebrated for its poetic question and its equally compelling response from the poem by Su Shi, "the bright moon, the cool breeze, and myself."

WOODEN BUILDINGS ELEVATED OFF THE GROUND . . .

The buildings in the gardens have an array of relationships with the ground and this relationship is exploited to great experiential richness. The higher the building is off the ground, the more important it is likely to be. Thus, the main halls are often, but not always, the highest while garden pavilions may be almost flush to the ground. In the residential courtyards, the buildings are accessed by a set of rectangular stone steps but in the garden, they are often reached by clambering up carefully placed natural stones that gently rise to connect with the floor.

. . . AND CROWNED WITH ROOFS OF FLYING EAVES

The flying eaves of the classical Chinese building assist in evenly distributing the weight of the roof onto the columns, essentially reducing the torque in ways similar to a cantilever. The height and extension of these eaves varies geographically throughout China with those in Suzhou being among the most exuberant.

The roofs are clad with ceramic tiles, which, in Suzhou, are a dark steely gray. The tiles are a series of cupped shapes fitted in an alternating concave and convex fashion and terminated with a drip tile that draws rain away

Figure 15. Construction detail of a flying eave.

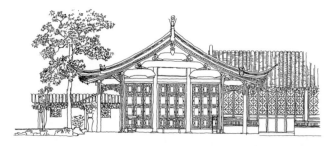

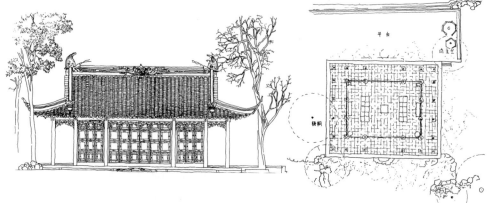

Figure 16. Plan and elevations of the Hall of Distant Fragrance, Humble Administrator's Garden. Timber frame halls typically have an odd number of column bays and masonry enclosed walls on the east and west sides.

from the roof and lets it fall harmlessly outward of the wooden columns and stone foundation. Rainy days bring these roofs alive with runnels of water cascading along each corrugated depression and then dripping with a sonorous "tink" onto the ground.

Figure 17. A well capstone in the Wang Garden, Yangzhou, is perched atop a shallow brick pyramid surrounded by a gutter that directs dirtied water away from the well-head.

WELLS

Neighbors in Suzhou and other nearby towns are called *jingli*, those who drink from the same well. The wells are the building blocks of the town, with both community wells and private wells carefully distributed to ensure equitable water supply. Wells in individual houses are commonly found in a small courtyard near the north end of the residence.

Groundwater contamination has reduced the uses for which well water can be used—now only nonpotable uses such as washing clothes. In addition to groundwater from wells, the inward sloping roofs of courtyard houses direct water into courtyards where it can be collected and stored in large pots to raise fish for food and to have water available to extinguish fires.

DWELLING IN THE GARDEN

The activities of daily life, however ennobled, were carried out between the high white walls of the Suzhou gardens. The integration of interior and exterior spaces, as not just a space that "flows" from inside to outside but a space where one is immersed in a density of sequential experiences, distinguishes these garden residences.

The purpose of each building retains a flexibility that is unusual in contemporary dwellings, where one sleeps in a predetermined space, eats in another, cooks in another, and meets with friends in another. In the garden residences, many of the buildings could be sleeping chambers as well as a place for friends to play strategy games. A simple portable brazier easily transforms courtyards into outdoor kitchens or teahouses. A wayward relative or a dear poet friend may reside in a garden pavilion for weeks or months. Special events, such as the Mid-Autumn Festival, described in this passage from *The Story of the Stone*, were celebrated in the garden pavilions.

"The moon must be up by now," said Grandmother Jia. "Let's go out and make our Mid-Autumn offering."

She got up and, leaning on Bao-yu's shoulder, led the way into the Garden. The main gate was wide open and hung with great horn lanterns. When they reached Prospect Hall, they found servants with lighted lamps waiting for them on the terrace and a table on which incense smoked in a square container and on which offerings of melons and other fruit and mooncakes had been set out on dishes. Lady Zing and all the other female members of the family were waiting inside the hall

Moonlight and lanterns gleaming pale
 Through a thin aromatic veil—

It was indeed a scene of indescribable beauty. A carpet for kneeling on had been laid on the terrace at the foot of the table on the side nearest the hall. Grandmother Jia washed her hands, lit some sticks

of incense, knelt down on the carpet, bowed down, and offered up the incense. The others followed her example.

"The best place for enjoying the moon from is the top of a hill," she told them when they had finished. She suggested the pavilion on the summit of the "master mountain" behind Reunion Palace (of which Prospect Hall was a part) as the place to have their party. . . . It was only a hundred or so steps up the zig-zag path to the summit.

The pavilion was a rectangular building with one completely open side looking onto a terrace. Because it was situated on the convex grassy summit of the little "mountain," it was called Convex Pavilion. Two tables with chairs round them had been set out on the terrace, separated from each other by a large screen. The tables and chairs, like the moon and melons and mooncakes, were all round, in honour of the occasion.

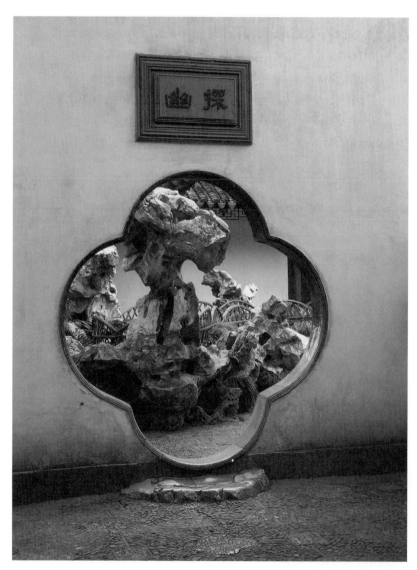

Figure 18. The flowering-crabapple-shaped gate at the Lion Grove, which artfully frames a group of stones called the Nine Lion Peak, is inscribed overhead with the tablet that reads "Looking for a Quiet Place." Note the small rock at the threshold which not only reinforces the ground where one steps but also pulls the courtyard rockery visually forward.

THE
Gardens
OF Suzhou

THE HUMBLE ADMINISTRATOR'S GARDEN

The Humble Administrator's Garden, sometimes referred to as the Garden of the Unsuccessful Politician, is the largest of the Suzhou gardens and is deeply enriched by its association with the esteemed Ming artist Wen Zhengming, who painted views of the garden while a frequent visitor.

The garden has three adjacent sections: the eastern, middle, and western gardens, with the middle garden being the most distinguished.

ORIGINAL ENTRANCE

The current entrance for visitors is through the eastern garden, but visitors should briskly walk through the east garden, enter the central garden, and continue to walk directly to the historic entry of the main residence—the entry hall with the ancient wisteria planted by Wen Zhengming as a gift to his friend, the garden's owner, Wang Xiachen. Begin your tour here by first looking across the street to see the screen wall that defines the entry courtyard of the house, with the street passing through. This architectural device is seen at several of the Suzhou gardens, but the one here is particularly elegant and generously scaled.

Walk north through the progression of hall and courtyards which are now a garden museum. Note the elevated walks at the center of the courtyards which provided dry footing from one pavilion to the next. The

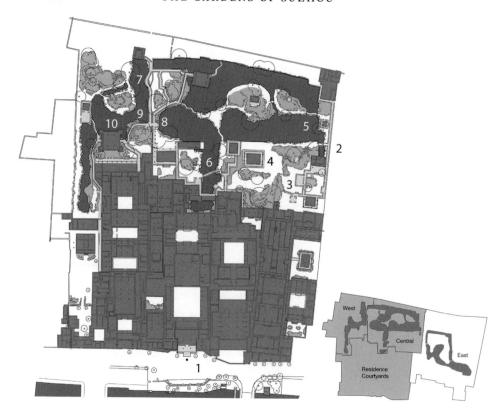

Figure 19. Plan of the central and western sections of the Humble Administrator's Garden and key plan showing relationship to the East Garden.

Central Garden
1. Former entrance to the residence
2. Contemporary entrance from the east garden to the central garden
3. Loquat Court
4. Hall of Distant Fragrance
5. Pavilion among firmiana and bamboo (borrowed scenery viewpoint)
6. Small Flying Rainbow Bridge
7. Winding garden corridors

West Garden
8. Moon gate connecting the Central and West Gardens
9. "With Whom Shall I Sit?" fan-shaped pavilion
10. Thirty-Six Pairs of Mandarin Ducks Hall

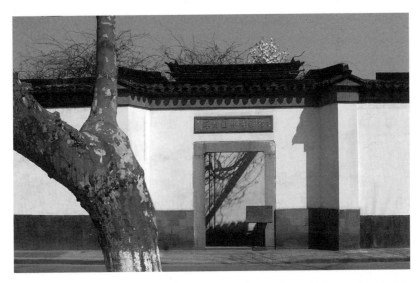

Figure 20. The original courtyard entrance to the residence includes the wisteria planted by the Ming painter Wen Zhengming, which is visible through the gate. Enter the contemporary visitor's entry but walk through the garden to start your tour of the Humble Administrator's Garden here.

courtyards exhibit a succession of tree species, often beginning with magnolia in the first courtyard, a flowering fruit tree such as peach or pear in the second courtyard, an autumn foliage tree such as a maple in the third courtyard, and a pine tree in the fourth courtyard. These trees mark the seasonal progression of spring, summer, autumn, and winter.

CENTRAL GARDEN

The celebrated central garden has four areas: the Loquat Court, the central pond, the winding corridors in the northwest corner, and the area of the flying bridge in the southwest corner. The central garden was built over a period of sixteen years beginning in the fourth year of the reign of Zhengde of the Ming Dynasty (1509), by the imperial inspector Wang Xiachen. Wen Zhengming painted thirty-one scrolls of the garden in 1533 and another eight scenes of the garden in 1551.

The garden's name, Zhuozheng Yuan, is taken from an essay by the Jin

Dynasty writer Pan Yue, "On Idle Living": "Building a house and planting trees, watering the garden and growing vegetables are the affairs (*zheng*) of humble (*zhuo*) people . . . To cultivate my garden and sell my vegetable crop is the policy of the humble man."

THE LOQUAT COURT

Walk so that you exit the north side of the residence at Loquat Court, a small garden with a pavilion to the east, a hilltop pavilion ahead, and a richly designed pavement in a cracked ice pattern. The pavement is among the most beautiful in any garden in China. A similar pattern is also used in the windows of the pavilion. To the northwest is a round gate the leads out to the large garden.

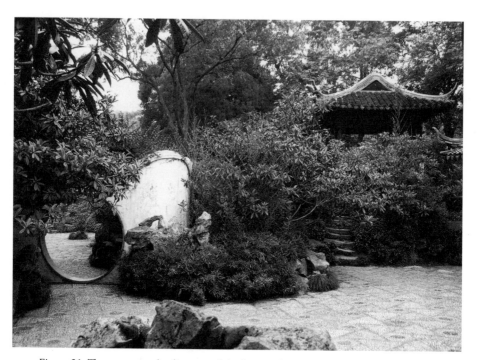

Figure 21. The moon gate leading out of the Loquat Court into the central garden.

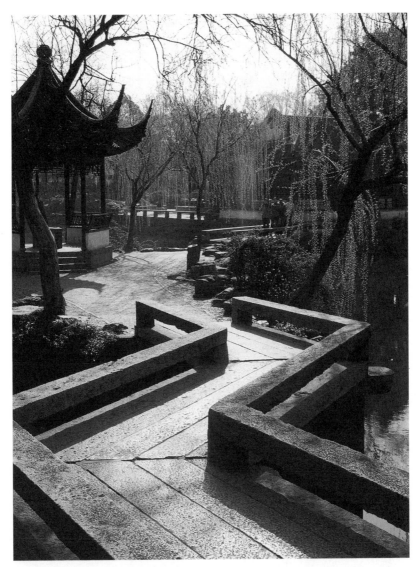

Figure 22. The zigzag bridge among spring willows in the central garden.

THE CENTRAL POND

Carefully look across the garden as you approach, pass through, and stand on the other side of the round gate to appreciate the framing of first, a single view through the gate, and then the panoramic scrolling scene that

emerges on the other side. From this location in the southeast corner of the Central Garden, one can scan from right to left in the manner of looking at a scroll painting and imagine that you are seeing rivers, lakes, and mountains. As with many gardens, this view looks across water to hills on the opposite shore.

The Hall of Distant Fragrance is just west of the round gate, and its name alludes to the aroma of lotus blossoms in the summer. At least ten buildings in the garden have names that reference lotus blossoms. Indeed, the pond is filled with lotus in the summer, and the allusion to the Buddhist proverb that states "even from the mud, beauty and honor may blossom" pervades the garden.

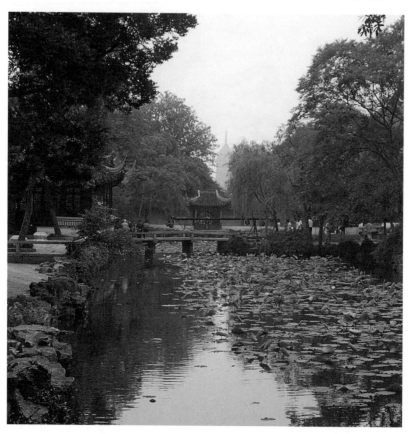

Figure 23. The borrowed scenery of the North Pagoda is seen across the pond from the east end of the central garden.

Walk counterclockwise around the central pond and stop at the pavilion at the east end of the pond and look west to see the North Pagoda, a superb example of borrowing scenery. Continue along the north side of the pond by walking up and down the hills to get a sense of the shifting views that a change in elevation can produce.

Small Flying Rainbow Bridge

The bridges of the central garden are particularly fine, especially the Small Flying Rainbow Bridge in the southwest corner of the garden. It is a rare wooden bridge in Suzhou and its exuberant flight across the water enlivens the narrow recessed space it commands. Spend some time walking around this quiet, compact corner of the garden, known as the small Surging Wave Pavilion after the older Suzhou garden by the same name.

Garden Corridors

An array of winding corridors occupy the northwest corner of the central garden. It is entertaining to walk up and down, and in front of and behind, the walls and columns that spatially define these.

Conclude your visit of the central garden at the unusually deep round gate at the west end of the pond that connects the middle and western sections of the garden. This is a particularly potent place in the gardens.

THE WEST GARDEN

As you enter the west garden, over your shoulder to the south are two pavilions perched atop a rockery which afford views back across the central garden—a prospect which was particularly effective when these two parts of the current garden were controlled by separate owners. A bending stream is directly beneath your feet and is marked by a pagoda-shaped stone. Across the water is a fan-shaped pavilion with the fan-shaped windows inscribed with a tablet that reads, "With Whom Shall I Sit?" To the north a particularly fine segment of corridor bends and dips down to a boat landing at the water's edge.

The west garden is also notable for the Thirty-Six Pairs of Mandarin

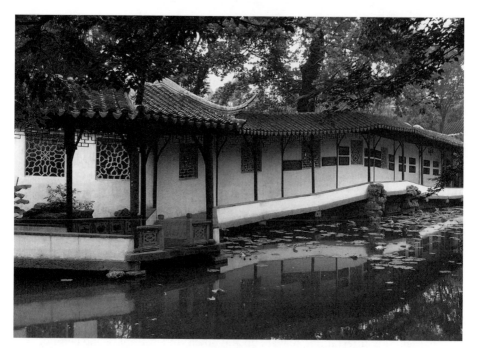

Figure 24. The garden corridor that separates the central and west gardens descends to a small boat landing adjacent to the pond.

Ducks Hall, with its paired square and round timbers alluding to the male and female ducks and their lifelong commitments to each other. This hall is the pivot point where the pond leads south into a small winding stream and densely planted hills to the southwest.

The west garden also includes a *penjing* garden with over seven hundred potted landscapes in the Suzhou style which merit study and admiration.

EAST GARDEN

The east garden is currently undistinguished, although a garden of some note was built there during the Ming Dynasty and some of the pavilions have been reconstructed and are worth visiting if time allows.

Figures 25, 26. Wen Zhengming (1470–1559), Garden of the Inept Administrator; Zhuozheng Yuan tu shi. Dated 1551. Album of eight painted leaves with facing leaves inscribed with poems; ink on paper. Each leaf: 10 ⅜ × 10¾ in. Gift of Douglas Dillon, 1979. The Metropolitan Museum of Art, New York. Image copyright © The Metropolitan Museum of Art / Art Resource, NY.

PAUSE AND OBSERVE: LANDSCAPE PAINTINGS OF WEN ZHENGMING

In the Ming Dynasty (1368–1644) court painters revived earlier Song Dynasty metaphors of the world as an imperial garden, while the scholar painters, inspired by the Yuan Dynasty painters' explorations in mental landscapes, pursued their own inner spirit. The Wu School of painting, which best typified the latter artists, was centered in Suzhou. The leader of the movement Shen Zhou (1427–1509), who with his celebrated follower, Wen Zhengming (1470–1559), lived and painted in Suzhou where they exercised self-cultivation away from the politicized imperial court.

Among the series of paintings completed by Wen Zhengming are two albums of the Humble Administrator's Garden which was owned by his good friend Wang Xiachen. The first album was completed in 1535 and included thirty-one views of the garden. The second album of eight views, completed in the autumn of 1551 when Wen was eighty-one years old, includes the two paintings shown in Figures 25 and 26.

Wen's album was comprised of the "three perfections" of poetry, calligraphy, and painting. Using only ink, he elegantly delineated the garden as a place of self-reflection.

ADDRESS

娄门东北街178号 Loumen Dongbei Street 178

LINGERING GARDEN

The Lingering Garden, a dense and intricate garden unmatched by any garden in Suzhou for its variety and intimacy of spaces, is widely regarded as the finest integration of architecture and garden in Suzhou. It also contains the Cloud-Capped Peak, the most acclaimed Tai Lake specimen stone in Suzhou.

AN ENTRANCE FULL OF TRICKS

The entrance sequence into the Lingering Garden, as Maggie Keswick remarked, is "full of tricks." The visitor winds to the north through a series of intimately scaled courtyards dense with columns, knee walls, overlapping roofs, thwarted vistas, and the aroma of magnolias or the sight of vivid plum blossoms.

The entrance corridor is immediately east of the residential courtyards. One arrives at the southeast corner of the garden in a room with carved windows that provide the first, veiled view into the larger garden. During the time that the families lived here, the Lingering Garden (and others in Suzhou) were periodically open to the public. This entrance was made especially for those visitors and remains the primary passage for visitors to the garden. For those with time and interest, it is worth walking this sequence several times in order to comprehend the richness of this small aspect of the garden.

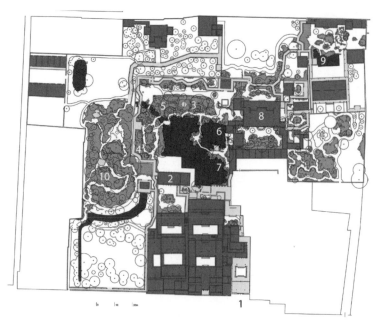

Figure 27. Plan of the Lingering Garden

Central Garden
1. Entrance
2. Mountain Villa
3. Twin ginkgo trees
4. Winding corridors and pavilion
5. Rockery
6. Refreshing Breeze Pavilion
7. Winding Creek Tower

Eastern Garden
8. Five Peaks Celestial Hall / Nanmu
 Hall
9. Cloud-Capped Peak (specimen
 stone)

Western Garden
10. Comfortable Whistle Pavilion

The Lingering Garden has four distinct areas. The central area, dating from the Ming Dynasty, is a mountain and water landscape surrounded by halls, pavilions, terraces, and a lively winding corridor. The eastern section is notable for the architecture of the halls and pavilions, especially the Celestial Hall of Five Peaks constructed with rare nanmu wood, and for the collection of towering rock specimens. The western section is a narrow ravinelike woodland garden with hidden corridors among large earthen hills planted with maple trees whose red fall foliage contrasts with the yellow fall foliage of the ginkgo trees across the wall in the central area. The northern area displays a potted *penjing*, tray scenery, collection.

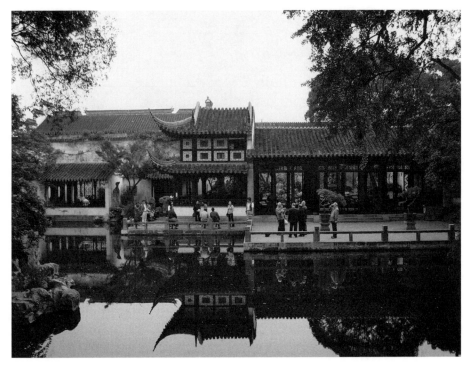

Figure 28. The Bright Zither two-story pavilion and the Mountain Villa overlook the south side of the pond.

MOUNTAINS AND WATER

The heart of the garden is a pond fed by small waterfalls flowing out of the rockeries in the northwest corner—a location that is consistent with feng shui, literally wind-water, preference for mountains to the north and west with waters flowing to the southeast. The relationship between the rockery and pond is especially fine here, with the preferred view of the rockery being from the terrace of the Mountain Villa on the south side of the pond.

Look out across the pond and slowly scan the scene from right to left. The vista shifts from a small boat moored in a limpid pool in the southeast to a tall white-walled hall, stone pagodas punctuating the water, a small peninsula with wisteria arbors, a tall rockery framed by towering twin ginkgo trees, and finally a winding corridor that rises from the north-

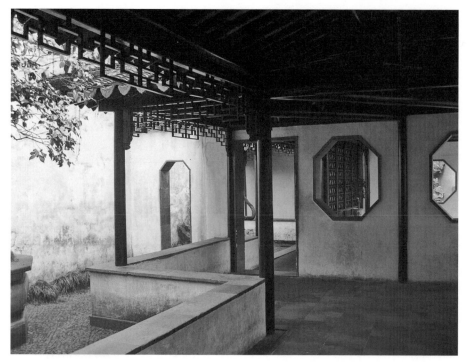

Figure 29. The visitor winds through a series of small courtyards and corridors to enter the garden.

west corner and emerges from behind the rockery. This slowly unrolling sequence is one of the most convincing scenes where the tradition of horizontally scrolling landscape painting is captured in a garden.

MAN-MADE MOUNTAIN

From the terrace of the Mountain Villa, walk clockwise around the pond along the winding corridor (part of more than seven hundred meters of winding corridors in the garden) that clambers up the western side. From the small pavilion at the high point of the corridor, a long diagonal view across the pond is directed to the southeast corner where a small, hidden boat landing is nestled against the entry hall. Walk down the hill and across the small falling streams and continue up onto the Ming Dynasty

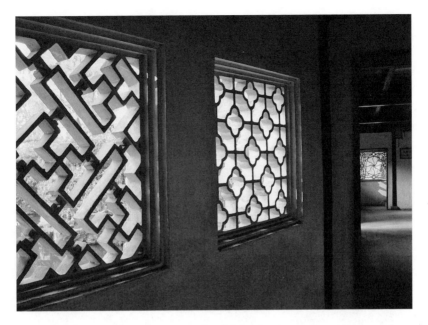

Figure 30. Carved brick windows conceal and delay the view to the garden beyond.

rockery made by Zhou Bingzhou. Wind in and around the rockery to get a sense of its many small landings, overlooks, passages, and concealed stairs.

EAST SHORE OF THE CENTRAL POND

A superb sequence of corridors, halls, pavilions, and studies stretches along the eastern shore of the pond. Beginning in the north, the Refreshing Breeze Pavilion, a small study hidden behind a corridor wall, overlooks a small lagoon dotted with stone pagodas. A two-story pavilion and a four-sided open pavilion look out onto the same lagoon. Alongside the pond and providing a small boat landing is the impressive two-story Winding Creek Tower. This sequence of architectural spaces concludes in the southeast corner of the garden at the passages that lead to the entrance. Walk back and forth through these intricate spaces of small rooms, sprite columns on stone bases, walls punctuated by lattice windows, and subtle shifts in the ground plane.

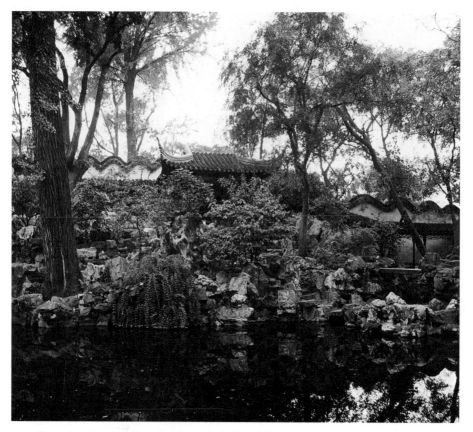

Figure 31. The view from the Mountain Villa is like a horizontally scrolling landscape painting.

FIVE PEAKS CELESTIAL HALL

The eastern area contains a notable collection of twelve Tai Lake limestone peaks (see Pause and Observe) distributed among a series of courtyards and two very fine halls. The first of these halls, the Five Peaks Celestial Hall, also named the Nanmu Hall for the rare species of wood from which it is constructed, is the largest hall in any Suzhou garden. An exuberantly carved screen divides the hall with the southern half overlooking a Ming Dynasty three-peaked rockery and the northern half facing a rockery surmounted by a lacebark pine.

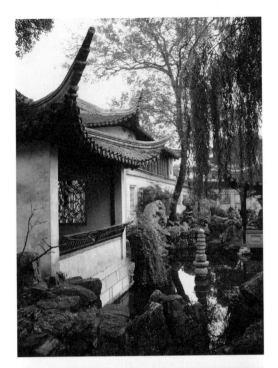

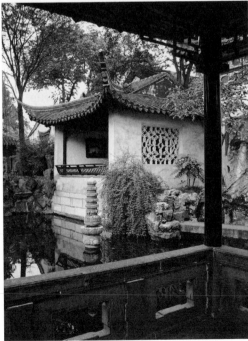

Figures 32, 33. Two views of the Refreshing Breeze Pavilion, a one-bay studio along the eastern edge of the pond.

CLOUD-CAPPED PEAK AND
OLD HERMIT SCHOLAR'S HOUSE

A dense collection of small studies fronting intimate courtyards separate the Five Peak Celestial Hall from the courtyard of the famous stone specimen, the Cloud-Capped Peak. The tall specimen stone commands the center of the courtyard, with a two-story hall to the north and the fine Old Hermit Scholar's House, the second of the architecturally significant halls in this part of the garden, to the south. This hall is also divided into two halves, north and south, by ornate wooden screens. The ceiling is particularly noteworthy. Each half has a separate ceiling with elegantly curved vaults where the deep reddish brown timbers are offset by the steel-gray ceiling tiles.

THE WESTERN AREA

Access to the western area is best gained from the western side of the Mountain Villa, the hall that sits on the south side of the pond in the central garden. A waterside pavilion overlooks a small winding stream, and a series of paths lead up the large earthen hill to a pavilion at the summit. From this pavilion, views to Tiger Hill and other Suzhou landmarks were formerly enjoyed prior to the views being enclosed by adjacent buildings. Today, views down into the central garden continue to reward the walk up to the pavilion.

COURT INTRIGUE

The earliest part of the Lingering Garden was built by Xu Taishi, a successful candidate in the imperial examination who became a supervisor of construction for the Ming tombs outside Beijing. He was accused of taking bribes during the construction of the tombs and impeached, although he was later vindicated. Upon returning to Suzhou, he began building a garden at his ancestral home—a garden whose primary form remains as the central area of the Lingering Garden.

WEST GARDEN (XI YUAN)

Xu Taishi also constructed a garden west of the current Lingering Garden. At the time, the two gardens were simply known as the East Garden and the West Garden (Xi Yuan). Today the West Garden is a Buddhist temple enclosed by saffron-colored walls. It is the largest temple in Suzhou and includes a notable garden centered on Fangsheng, or Free Captive Animals Pond (with turtles reputed to be three hundred years old), as well as a Ming Dynasty hall with five hundred *arhats*, Buddhist disciples who have achieved nirvana. It is interesting to consider how easily some of the gardens in Suzhou, such as the West Garden and the Lion Grove, have changed from temple gardens to private gardens and vice versa.

PAUSE AND OBSERVE: ROCK SPECIMENS

The Lingering Garden houses the most significant collection of rock specimens in Suzhou. Among these stones is Guanyun (Cloud-Capped Peak). At six-and-a-half meters in height, it is the tallest stone in any Suzhou garden and arguably the most revered. The stone, which commands a courtyard outside a hall with the same name, is flanked by two complementary rocks: Ruiyun (Auspicious Cloud) and Xiuyun (Caved Cloud).

The stone, like similar limestone specimens, was collected from the karst geological formations of Tai Lake approximately thirty-five miles, or sixty kilometers, west of Suzhou. The action of waves on the soft limestone carved crags and bored holes in the rock. Stones were also "seeded" with smaller rocks and skilled craftsmen cultivated and enhanced the fantastic shapes.

The intricacy of the voids and their location on the stone contributes to the renown of this specimen. The lower third of the stone is solid with one deep recess. The center third is offset from the base in a way that adds vitality to shape of the stone. The upper third reaches high into the sky with a dramatic hole that frames the sky overhead. This hole is framed by shallow linear scrapes in the rock that express the vigorous life force, or *qi*, that is so admired in stones.

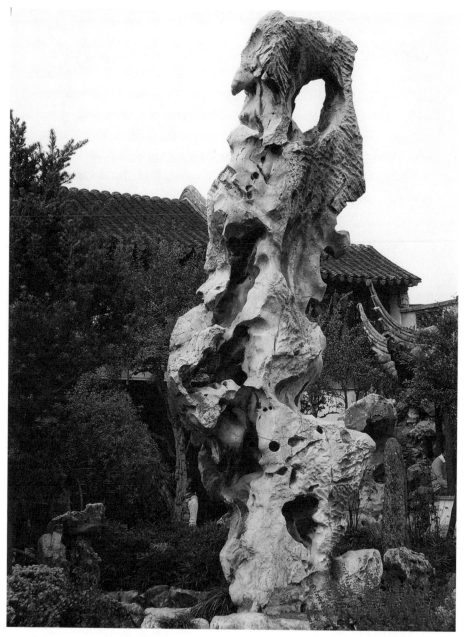

Figure 34. The Cloud-Capped Peak, arguably the most renowned Tai Lake stone in China, commands the courtyard of the hall with the same name. The balance of solid and void, the compelling hole worn through the top, and the sheer size of the stone (the tallest in Suzhou) contribute to its fame.

ADDRESS FOR LINGERING GARDEN

留园路338号, Liu Yuan Street 338

ADDRESS FOR THE WEST GARDEN TEMPLE

留园路西园弄18号, Liu Yuan Street, Xi Yuan Alley 18

LION GROVE

Lion Grove, sometimes referred to as the Lion Forest, is a former temple garden dominated by an exuberant rockery with dozens of upright stone "lions" gathered around the central pool. The confounding routes of paths through the rockery are remarkable for their variety, richness, and surprises.

TEMPLE GARDEN

The garden was originally laid out behind the Lion Grove Temple, founded by the Buddhist monk Tianru Weize (1286–1354) during the Yuan Dynasty. Lions are potent Buddhist figures, and the name of the temple also referred to the mountain retreat of Tainru Weize's teacher Zhongfeng. The rockery dates from this very early garden and is thus one of the oldest remaining in China. Spend most of your time in the garden exploring the nine trails and twenty-one grottoes in the rockery.

The Lion Grove is the model for Lion Grove rockeries constructed by the Qing Emperor Qianlong at the Yuanming Yuan in Beijing and at the Mountain Resort in Chengde, north of Beijing—the latter of which has survived.

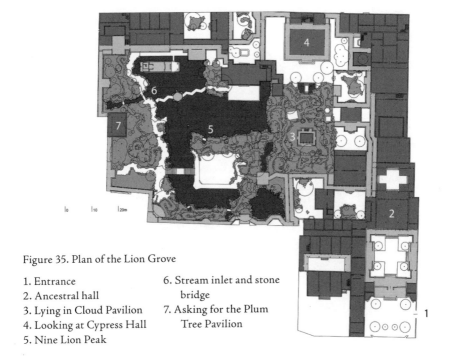

Figure 35. Plan of the Lion Grove

1. Entrance
2. Ancestral hall
3. Lying in Cloud Pavilion
4. Looking at Cypress Hall
5. Nine Lion Peak
6. Stream inlet and stone bridge
7. Asking for the Plum Tree Pavilion

TWENTIETH-CENTURY ANCESTRAL HALL

Entry to the garden is through an ancestral hall and series of courtyards built by Bei Runsheng in the period just after the fall of the Qing Dynasty in the early twentieth century. Bei Runsheng is the uncle of the Chinese-American architect Bei Ieoh Ming (I. M. Pei), who spent part of his childhood in the garden and whose nearby Suzhou Museum continues a familial legacy in the building of the gardens of Suzhou.

THE ROCKERY

The rockery occupies about half of the entire garden. It surrounds, and at times leaps into, a central pond that seems uncomfortably crowded and broken into pieces. It is one of the least successful water bodies in Suzhou gardens.

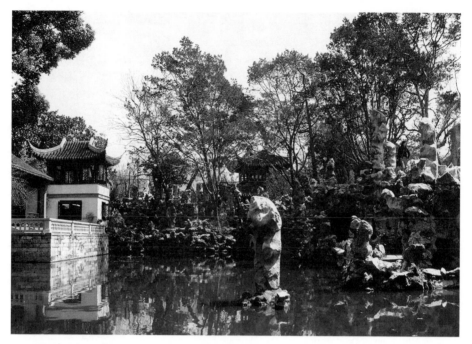

Figure 36. Looking east to the exuberant stone lions rockery formations.

The major part of the rockery is on the eastern shore of the pond and is topped by the Lying in Clouds Pavilion, a four-sided pavilion that is easy to see—but very hard to get to. Intertwining paths, tunnels, head-bumping clearances, hidden chambers, and clever turns in the paths confound one's attempts to reach the summit—which makes the final success in reaching the pavilion all the more satisfying. Don't take any shortcuts.

NORTHWEST CORNER

The primary hall in the garden, the Looking at Cypress Hall, is tucked behind the rockery in the northeast corner of the pond. Arriving at the serene terrace in front of the hall after a climb on the rockery marks a profound shift. A four-lobed flowering crabapple shaped gate on the east side of the terrace is particularly fine and leads to an equally elegant, and even quieter, courtyard.

WINDING CORRIDOR

Along the southern, western, and northern perimeter of the garden a winding corridor hugs the enclosing wall of the garden. This corridor has less vitality than the ones at the Lingering Garden or Humble Administrator's Garden, but nevertheless it provides fine vantage points to survey the garden. A half-attached pavilion sits high above the southern edge of the pond, and a fan-shaped pavilion overlooks the southwest corner. An unsuccessful pavilion and inelegant stone boat, both from the early twentieth century, are situated to the west and northwest of the pond along the corridor.

PAUSE AND OBSERVE: LARGE TREES

A towering camphor tree commands the northeast corner of the Lion Grove and an equally impressive ginkgo stands sentinel over the western side of the pond. These trees, apart from their noble stature as ancient trees, add verticality to the garden spaces and bring welcome shade in the humid Suzhou summers.

The main rockery of the Lion Grove is planted with another forest—of lacebark pines. The predominant use of a single species provides unity to this riotous part of the garden, and the lovely chromatic resonance between the silver-gray rocks and the pine's dusty green needles and bark of camouflage-patterned white, silver, and russet is especially refined. This monochromatic tonality among plants and rocks may be found in the influential paintings of the Tang painter-poet Wang Wei and his successors.

On many trees, one will see green or red labels. Green labels designate trees that are more than one hundred years old, and red labels are reserved for specially protected trees more than two hundred years old.

ADDRESS

园林路23号, Yuan Lin Road 23

Figure 37. The largest elements of gardens are mature trees which add spatial structure, shade, aroma, and literary allusions. A camphor tree towers over the corner of the Lion Grove and gathers the rockery, pond, and hall under its spreading canopy.

Figure 38. The branching structure and shadows of trees stand out against the white walls of Suzhou gardens.

SURGING WAVE PAVILION

The Surging Wave Pavilion has the longest history of any of the remaining gardens in Suzhou with its conception dating from the Song Dynasty construction of the Canglang Ting, or Surging Wave Pavilion, alongside the canal that now fronts the north side of the garden. Canglang Ting, whose name is derived from a poem in the anthology *Songs of Chu*, is also known as the Deep Blue Wave Pavilion.

A large hill, stretching east-west, occupies the middle of the garden and is encircled by the renowned winding corridors. The corridors rise and fall with the topography to make an experientially rich circumnavigation of the hill. The corridor along the canal, a notable double corridor, opens the garden to the city—a rare instance in Suzhou gardens where the walls of the garden do not fully exclude the immediate city outside the walls.

BETWEEN THE WATER AND A MOUNTAIN

The garden is approached across a canal bridge from which the corridors and pavilions west of the entrance can be seen. Like the hill described in *The Story of the Stone*, the three-hundred-year-old Chinese literary classic, the hill at Canglang Ting immediately confronts the visitor and causes one to divert around it. A character in the novel remarks on the fictive hill in

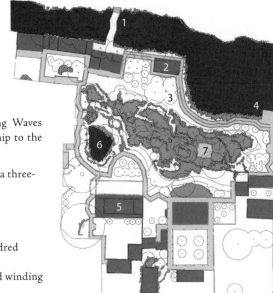

Figure 39. Plan of the Surging Waves Pavilion, showing its relationship to the canal.

1. Entrance across the canal on a three-bend bridge
2. Facing the Water Pavilion
3. Double Corridor
4. Watching Fish Pavilion
5. Memorial Hall for Five Hundred Scholars
6. Cup garden of deep pond and winding corridors
7. Surging Wave Pavilion

the novel, "If not for this hill, one would see the whole garden as soon as one entered, and how tame that would be." Upon entering Canglang Ting, move clockwise around the hill by first walking along the double corridor (note its 108 windows) that is compellingly situated between the canal outside the garden and the hill inside the garden—between water and mountain. At the northeast corner of the garden, where the double corridor ends, a small pavilion sits out over the canal with a panoramic view to the neighborhood beyond.

HALLS AND COURTYARDS

Continue to walk clockwise toward the halls and courtyards (see Pause and Observe) south of the hill. The Enlightenment Hall looks north toward the hill and south toward the courtyard. Adjacent to it is the Hall of Five Hundred Sages, which contains an important collection of carved portraits of five hundred sages.

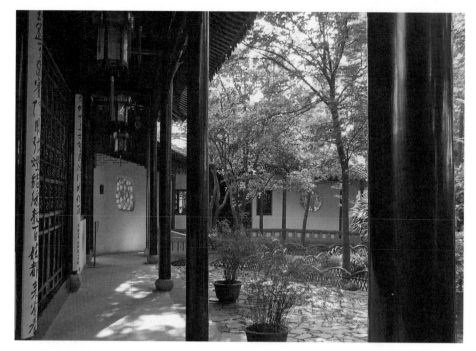

Figure 40. A winding double corridor runs between the canal and the garden.

CUP GARDEN

On the west side of the garden, the corridor rises and falls like a roller-coaster as it wraps around a cup-shaped pond. Mounted on the corridor wall at the north end of this segment are imperial stele by the Emperor Kangxi surmounted with finely carved marble panels.

THE HILL

Climb atop the hill from which a prospect into the lower gardens and courtyards can be seen. The garden of Canglang Ting is unusual among the gardens of Suzhou in that an earthen, forested hill is at the center of the garden. With few exceptions, it is water that lies at the center of other gardens.

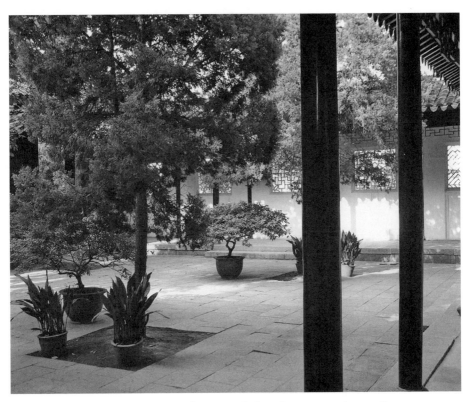

Figure 41. Paved stone courtyards commonly have four trees and pots of temperate climate plants.

At the summit of the hill is the Surging Wave Pavilion, after which the garden is named. This pavilion was originally situated alongside the canal as part of the garden built by Su Shunqing. The pavilion was moved atop the hill during the garden renovation undertaken in the thirty-fifth year of the reign of Kangxi, in 1696. The graceful eaves of the pavilion turn up at the corners and reach a terminal height almost equal to the ridge of the roof. From this lofty position, one would expect an exceptional distant view, but the pair of halls to the south crowd together and obstruct any possible prospect south of the garden.

Descend the hill on the east side and revisit the small pavilion in the northeast that overlooks the canal. Return to the gate along the double corridor by walking in and out along each side of the dividing wall.

PAUSE AND OBSERVE: COURTYARDS

Courtyards commonly lie at the center of Chinese residences—whether it is a rural farm or an imperial palace. These private domestic landscapes are often divided into four quadrants by walks centered on doors or corridors. At the Enlightenment Hall at Canglang Ting, as with many such courtyards, four trees mark each quadrant. Fruit trees are often planted here to provide food, although magnolia and pine are also common due to their fragrance or evergreen character signifying longevity. Tender flowering plants, usually flowering shrubs such as azaleas, are planted in bell-shaped pots.

ADDRESS

三元坊沧浪亭街3号, San Yuan Fang, Canglang Ting Pavilion Street 3

网师园
WANGSHI YUAN

MASTER OF THE NETS GARDEN

The Master of the Nets Garden is a finely detailed small garden whose origins extend back to the Song Dynasty. The three-courtyard residence elegantly exemplifies the social and familial order of the retired scholar. The relationship between the halls and pavilions in the garden to the square-shaped pond is noted for their variety of being "on, against, near, overlooking, and secluded from" the pond itself.

SONG DYNASTY HALL OF TEN THOUSAND VOLUMES

The desire for the beauty of nature and to retreat from city life—especially the treacherous imperial bureaucracy—motivated Shi Zhengshi to retire from his Southern Song Dynasty bureaucratic post and build his Hall of Ten Thousand Volumes and the adjacent garden, "Fisherman's Retreat." He cultivated flowers and read books in the garden where he modeled himself as the content fisherman, the Chinese equivalent of the arcadian shepherd of the West, often depicted in Chinese philosophy and paintings. The Song Dynasty painter Guo Xi (c. 1020–c. 1090) wrote, "Always prefer a garden to cultivate the mind and to live in, lofty mountains and waters to inspire the heart, seek the pleasure and comforts of the fisherman and woodcutter, and stay away from the hectic city life that imprisons the mind."

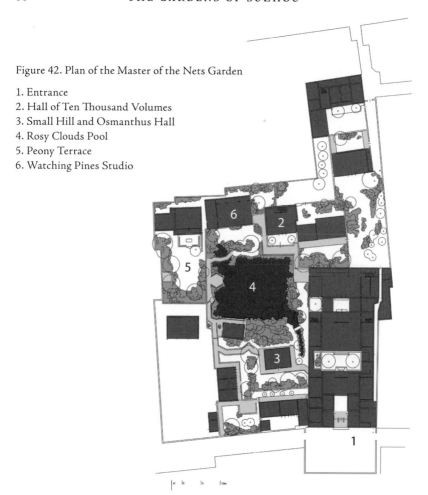

Figure 42. Plan of the Master of the Nets Garden

1. Entrance
2. Hall of Ten Thousand Volumes
3. Small Hill and Osmanthus Hall
4. Rosy Clouds Pool
5. Peony Terrace
6. Watching Pines Studio

A HISTORY OF NEGLECT AND RECONSTRUCTION

A short review of the garden's ownership will illuminate similar histories of early established gardens of Suzhou—where the vicissitudes of dynastic change, bureaucratic savviness, and fluctuating prosperity all contribute to the rise and fall of the gardens.

Around 1785, during the reign of Qianlong and centuries after Shi Zhengshi built his Hall of Ten Thousand Volumes, another minesterial official, Song Zongyuan, built his courtyard residence on the site and named it the Master of the Nets Garden to express his desire, like Shi

Zhengshi, to lead a hermit-like life. He organized the residence around twelve scenes, including the Washing My Tassels in the Water Pavilion and the Small Hill and Osmanthus Fragrance Pavilion, which established the south side of the garden as the focus for entertainment. The northern side of the garden, the historic location of Shi's Hall of Ten Thousand Volumes, was the focus for scholarship.

A wealthy merchant from nearby Taicang, Qu Yuancun, purchased the garden ten years later in 1795, and added halls, pavilions, and terraces. When the peonies were in bloom in the spring and summer, Qu invited scholars to enjoy the aroma and sight of the flowers. Passersby could hear them playing music and reciting poems behind the high white walls of the garden.

The garden returned to another administrative official, Li Hongyi, in 1868 following the Taiping Rebellion. Li owned an extensive library and was also skilled at calligraphy. Many of the inscribed stelea in the garden are his copies of Wei and Jin Dynasty inscriptions.

The last private owner, He Cheng, restored parts of the residence and garden during the optimistic time between the fall of the Qing Dynasty in 1912 and the Japanese occupation in 1936. During part of this time, the Zhang brothers, both famous painters, had their studio in the Peony Terrace. The garden was donated to the government after He's death in 1946 along with a notable collection of calligraphy, paintings, and furniture. In the 1970s, the garden was purportedly occupied by Kang Sheng, a powerful intelligence specialist and important figure in the Cultural Revolution between 1966 and 1976.

The garden, thus embodies common histories of the Suzhou gardens. A small early pavilion and garden in the Song Dynasty was expanded in the Ming Dynasty by successful scholars who had performed well on the imperial exam in their youth and later retired from court life in Suzhou. Periods of destruction were experienced during the upheaval that led to the rise of the Qing Dynasty. The mid-Qing era was marked by prosperity, and the gardens of Suzhou and elsewhere flourished. The nineteenth and twentieth centuries, however, brought foreign armies, the internal Taiping Rebellion, the fall of the Qing Dynasty, a world war, and revolution that damaged or destroyed the gardens once again.

A SERIES OF COURTYARDS

The residence occupies the eastern third of the garden and includes a series of courtyards and pavilions. The entrance to the garden is gained from an elegantly proportioned external courtyard through which passes Kuojiatou Lane. Rings to tie up horses are embedded in the walls of the courtyard. The entrance is into a sedan chair hall. A carved stone tablet over the small door on the west side of the hall reads *Wangshi Xiaozhu*, "Small House for a Fisherman." This door is one of the entrances to the garden and the one most commonly used for formal visitors.

A courtyard separates the sedan hall from the Hall of Ten Thousand Volumes, named after a previous building in the garden, On the south side of the courtyard is an exquisitely carved brick gate. The interior of this hall is filled with the refined collection of art and artifacts enriched with the literary allusions of erudite scholars formally arranged around a seating group for the owner to welcome distinguished guests.

Close friends would be welcomed to the next courtyard and hall, the Beauty Within Reach Tower, in the sequence. Here, more casual encounters would be held. In the northeast corner of this hall is another entrance to the garden—one for close friends and family—that leads to a small pavilion that gives an expansive panoramic view west across the bright pond.

TWO DOORS INTO THE GARDEN

If time allows, enter the garden through the sedan hall door first. Later, return to the Beauty Within Reach Tower, and enter the garden again to observe the distinction between entering the garden as a formal visitor and as a close friend or relative.

SOUTH OF THE POND

Entering the garden from the sedan hall, one enters an enclosed, claustrophic space with confounding corridors, short focal distances, and dense

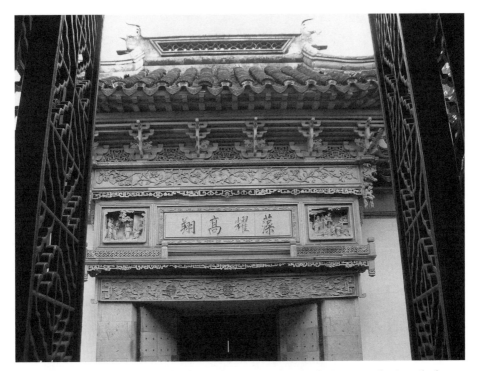

Figure 43. The large carved brick gate facing inward to the first courtyard is inscribed "Soaring Literary Accomplishments."

planting that conceals the sky. The southern half of the central garden includes places for entertaining and music such as the Hall of Harmony and the Lute Chamber. Also embedded in this part of the garden is the Small Hill and Osmanthus Hall, where formal visitors into the garden would be left with a mysterious lack of awareness of what lies beyond (see Pause and Observe).

THE ROSY CLOUDS POOL

The center third of the garden gathers around the Rosy Clouds Pool, which is ringed by halls, pavilions, corridors, rockeries, and terraces which sit close to the water. The pond is almost square in shape, with a zigzag bridge in the northwest across a small cove that hints at the source of the

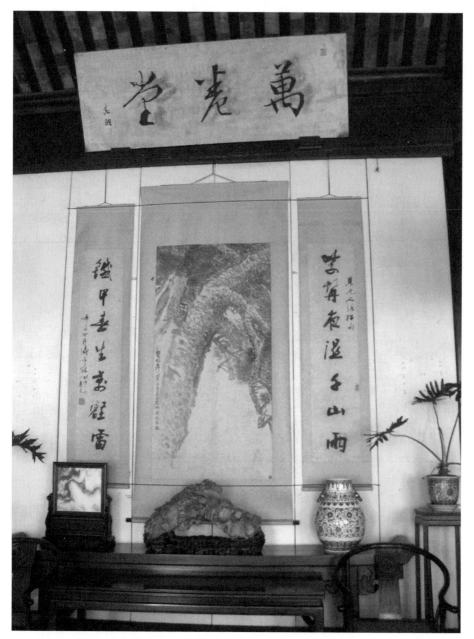

Figure 44. The reception hall displays calligraphic tablets, poetic couplets that flank an inkbrush painting, specimen rocks, rock screens, and porcelain vases.

pond as a spring and another tiny arched bridge across a narrow stream in the southeast corner of the pond that hints at the outlet of water from the garden.

There are four pavilions from which to overlook the pond, one on each side. The variety of relationships among the surrounding structures to the pond is noteworthy. Advancing structures, such as the Washing My Tassels in the Water Pavilion to the south; overlooking pavilions such as the Moon and Breeze Pavilion to the west; and receding structures, such as Watching Pines Pavilion in the northwest, enliven the relationship of garden buildings to the pond in this garden.

THE PEONY TERRACE

The western third of the garden was established as a peony nursery by Shi Zhengshi and now includes the Late Spring Cottage. The small courtyard was the model for the Chinese courtyard constructed in the Metropolitan Museum of Art in New York. A half pavilion attaches to the west wall of the courtyard adjacent to a small spring. The east wall of the courtyard is notable for the ingenious manner in which the roof tiles of the pavilion on the opposite side pierce through the wall and scupper rainwater from one side of the wall to the other. Another instance of this can be seen in the area south of this courtyard.

NORTH OF THE POND

The northern half of the central garden includes places for painting and scholarship such as the Watching Pines and Appreciating Painting Studio, the Meditation Study, and the Five Peaks Library. The painting studio overlooks a small terrace graced by a tortuous pine tree beside the zigzag bridge. A short winding corridor connects this part of the garden with the residential courtyards. Along this corridor are the distinctive waterside seats with an inclining rail.

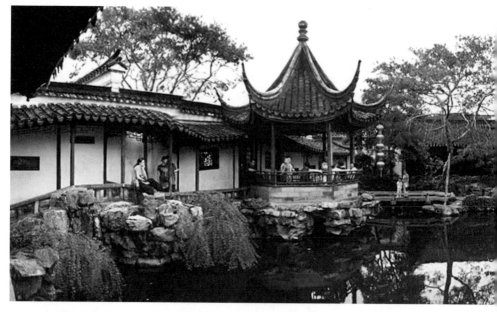

Figure 45. The Rosy Clouds Pool is the center of the garden. (Photo by Steffi Ruff)

Figure 46. One of the author's favorite details in all of the gardens is visible in the Peony Terrace where the roof from the pavilion on the other side penetrates the wall and delivers rainwater to a small planting bed on this side.

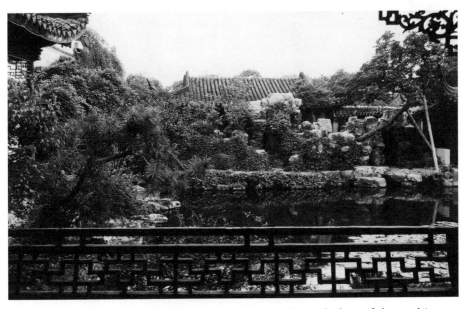

Figure 47. The Small Hill and Osmanthus Hall on the south shore of the pond is concealed by the rockery when observed from elsewhere in the garden.

THE NORTHEAST CORNER

In the northeast corner of the garden is a two-story pavilion, the upper story of which is the primary sleeping quarters for the family. Another private pavilion overlooks a long courtyard to the south. Behind it are the kitchen, living quarters for domestic help, and a back entrance with a service alley.

PAUSE AND OBSERVE: HALLS

The Small Hill and Osmanthus Hall is open on all four sides but it feels like one is in a cave. A rockery to the north fills the carved windows like

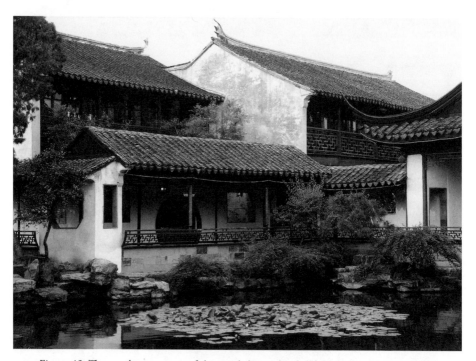

Figure 48. The northeast corner of the pond shows the skillful relationship among the volumes and roofs of two-story pavilions, large halls, corridors, and small pavilions. The buildings are enclosed with high masonry walls on the east and west ends and a screen of wooden doors and windows on the south.

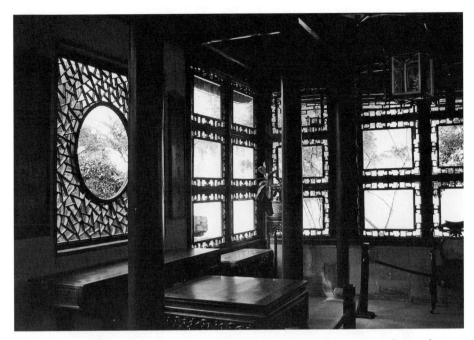

Figure 49. Flower blossoms, tree branches, rockeries, and shadows aggressively intrude into the orderly interior of the Small Hill and Osmanthus Hall, named for the stone rockery to its north and the osmanthus-filled courtyard to its south.

Figure 50. Cross-section through the Small Hill and Osmanthus Hall, looking west, shows the hall enclosed to the south (left) by a wall that is the same height as the eaves and a densely planted courtyard —and, to the north (right), by a rockery that is constructed tightly against the building so that it consumes any view out of the hall. The rockery is also eave height and located just far enough away from the roof that southern sunlight can shine upon it and cast deep, contrasting shadows. (After Liu Dunzhen, Chinese Classical Gardens of Suzhou.)

Figures 51, 52. Carved windows of the Small Hill and Osmanthus Hall frame views of small specimen stones (top) and the rockery (bottom).

paintings of mountains. The tall wall on the east presses against that side of the hall and captures shadows like ink wash paintings of bamboo and autumn leaves. Dense osmanthus grows among a long, low rockery that fills the courtyard to the south and west. Visitors are treated to a foreground panorama consumed entirely with aspects of the garden just outside the hall collapsed onto and framed by the richly carved windows of the exterior wall.

The garden assaults the interior, pressing forward, threatening to invade the room rather than lying in repose to allow long views out and through a more supine landscape. This potent relationship of garden and room is a defining characteristic of Chinese gardens, and the Small Hill and Rockery Hall conveys with great clarity the resonance between an active landscape and an orderly, restful room.

The hall, like others in the gardens, was built as a detached parlor for entertaining family and guests. These are the largest, most formal of the garden pavilions and are located near where visitors would enter the residence.

ADDRESS

沧浪区阔家头巷11号, Canglang District, Kuojiatou Lane 11

怡园
YI YUAN

GARDEN OF HARMONY

The Garden of Harmony, sometimes referred to as the Happy Garden, the Garden of Pleasance, or the Pleasant Garden, is a late Qing garden with a few notable attributes—perhaps the most appealing being the double-sided corridor with carved windows that divides the garden into east and west sections. The design of the garden also cleverly borrows many aspects of earlier Suzhou gardens.

DOUBLE-SIDED CORRIDOR

The eastern section, which one enters from the gate off busy Renmin Road, was a Ming residence. The western section, dating from the Qing Dynasty, is the main part of the garden and is entered at either the north or south end of the double-sided corridor. It is advisable to find your way to either end of this corridor and then walk along the eastern side—periodically glancing through the carved windows to the western garden. Complete the walk along the eastern side and then retrace your path on the western side, turning your sight from the pond and pavilions of the western garden to the more domestic scenes of the eastern half.

Walk clockwise from the southern end of the double corridor to the large hall on the south side of the pond. From the terrace, there is a view to the rockery on the north side. This relationship between hall and rockery is ideal because the viewer can look away from the sun while the bright

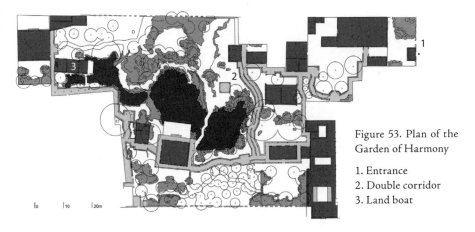

Figure 53. Plan of the Garden of Harmony

1. Entrance
2. Double corridor
3. Land boat

sunlight catches the face of the rockery and exaggerates the shadows and depth of the stones.

A boat-shaped pavilion, one of the finest in Suzhou, is moored in a small inlet west of the central pond. Behind it is a large ancestral hall. Continue clockwise around the pond by proceeding through, over, under, and against the rockery and arrive back at the double-sided corridor.

PAUSE AND OBSERVE: GARDEN WINDOWS

Carved brick or wooden garden windows punctuate the corridors and walls of Suzhou gardens to allow veiled views between spaces and the circulation of breezes. The patterns vary from intricate geometries, to shapes derived from leaves and blossoms, to metaphorical shapes derived from calligraphy. The designs rarely repeat but are often grouped thematically to reinforce a literary or philosophical allusion. The light passing through the windows, across the winding corridors, and onto mosaic pavements creates a sharp contrast between dark and light that is otherwise missing in the humid, misty light of Suzhou.

ADDRESS

沧浪区人民路1256号, Canglang District, Renmin Road 1256

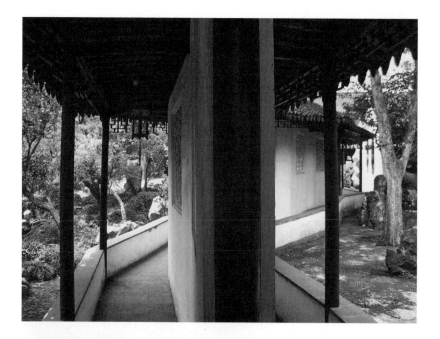

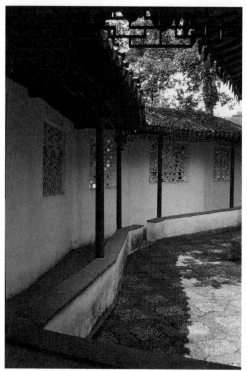

Figures 54, 55. A double-sided winding corridor, modeled on the Canglang Ting corridor, divides the orthogonal, Confucian residential courtyards and the more inflected, Daoist, arrangement of ponds, hills, and pavilions in the garden.

耦园

OU YUAN

THE COUPLE'S GARDEN

The Couple's Garden, sometimes referred to as Twin Garden or the Couple's Retreat Garden, is situated on the eastern edge of the old city and is surrounded on three sides by canals with the high, white enclosing walls of the garden constructed directly atop the granite walls of the canals. The relationship of the garden to the canals here is perhaps the most potent in all the gardens of Suzhou.

EASTERN GARDEN

The garden is divided into eastern and western parts with the eastern half being the oldest and most distinguished part of the garden. The eastern half is directly adjacent to the canals and separated from them only by the high wall punctured by carved windows that allow additional glimpses beyond the garden to the water and city outside.

Entrance to the residence is through a gate in the south wall—in keeping with the preferred orientation for entrances in much of China. Inside the gate, a carved plaque above the doorway reads *ping quan xiao yin*, or, Small Retreat of the Peaceful Stream. A sense of liquidity permeates the experience of the garden.

A series of three halls: the sedan chair hall, the reception hall, and the grand hall front a succession of courtyards progressing north. Guests

Figure 56. Plan of the Couple's Garden showing relationship to surrounding canals.

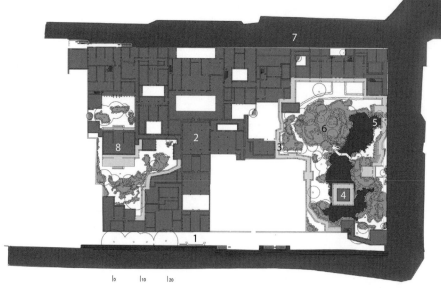

1. Entrance
2. Carrying Wine Hall

East Garden

3. Carved couplet
4. Among Mountains and Water
 Pavilion

5. Sun and Moon Viewing Pavilion
6. Rockery
7. Quay

West Garden

8. Old House with Woven Curtains

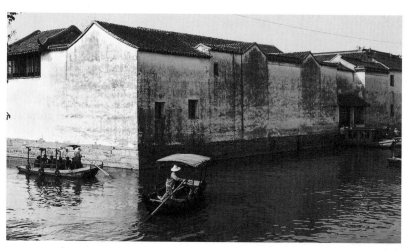

Figure 57. A quay (right) gives direct access to the canal from the north side of the garden.

would be welcomed in the reception hall and this is the primary space connecting the Eastern and Western Gardens. The high horizontal tablet in the hall reads *zai jiu tang*, or Carrying Wine Hall. It is flanked by a couplet mounted on the columns which translates as "Finding flowers in the small field road in the south. Raking leaves in the field road in the north." A second couplet is mounted on the wall flanking a painting of a couple drinking under a tree. This couplet translates as "Carrying wine in the East Garden and drinking in the West Garden."

A three-bay pavilion marks the transition to the East Garden. A couplet carved in the brick, composed by the wife, Yan Yonghua, frames the window on the east side of the pavilion (see Pause and Observe). The garden is infused with the love of this couple and it is perhaps the most personal and intimate of the Suzhou gardens.

A yellow stone rockery occupies the northwest quadrant of the East Garden, and a long pond stretches north-south through the center. Corridors encircle the west, south, and east sides and a large hall encloses the north side of the garden. At the southern end of the pond, the Among Mountains and Water Pavilion sits astride the water which flows beneath it to create another small pond. Inside the pavilion, a carved wooden screen—Three Friends of Winter: Plum, Bamboo, and Pine—divides the room. This robust carving is considered one of the finest Qing carvings in Suzhou. The small pond is also enclosed by another pavilion and the previously mentioned Watching for Scullers Tower. From here one can ascend into the tower to survey the everyday activities occurring outside the garden.

Along the east wall of the garden are two pavilions which are linked by a covered corridor. The northernmost pavilion, the Sun and Moon Viewing Pavilion, affords the longest view in the garden—a diagonal prospect across the pond that opens to the southern sky.

A large hall encloses a terrace and small meadow that looks south over the garden. Here, one can ascend to the Sun and Moon Tower for a view to the canal and city or access the quay along the narrow corridor in the northeast corner of the terrace. From this quay, one can purchase a short ride on one of the boats that ply the waters of the canal and return to the garden.

ROCKERY

The rockery in the East Garden is among the finest yellow stone rockeries in Suzhou and was likely built by the Ming Dynasty rockery master, Zhang Nanyang. The rockery is steep with precipices on the east where the proportional relationship of the rockery to the pond is particularly good. The yellow stone is hard and angular and establishes a strong contrast with the still pool. The rockery steps down to the west across a narrow ravine that cuts through the center. The west side of the rockery is filled with soil and plants and is less artful than the eastern side.

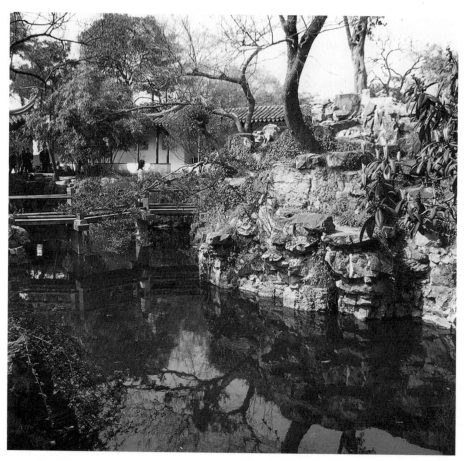

Figure 58. The proportional relationship of the steep rockery to the width of the pond is especially harmonious.

WEST GARDEN

In the West Garden are a series of courtyards and pavilions, including the Crane and Longevity Pavilion to the southeast and the Library Tower to the north. In the center of the West Garden is the *zhi lian lao wu*, the Old House with Woven Curtains, a three-bay pavilion surrounded by small limestone rockeries. The implications of the West Garden is of a couple content to weave curtains and read and write poems encircled by woods and mountains. Shen and Yan did that for only eight years before he was beckoned back into government service and the couple moved from Suzhou and left behind their garden retreat.

PAUSE AND OBSERVE: POETIC COUPLETS

In the novel *The Story of the Stone*, one of the chapters is titled "Literary Talent Is Tested by Composing Inscriptions" and reads in part: "If no inscriptions on tablets are made for the several pavilions and halls in the garden with such splendid views, even flowers, willows, hills and ponds will fail to add color to it." Only after an inscription was composed and written on stone panels, wooden tablets, or bamboo strips was the garden scene completed.

The wife, Yan Yonghua, composed the couplet that is the source of the Couple's Garden's name. Each line of the couplet begins and ends with homophones (*ou* for the first line, *cheng* for the second). The character "ou" can mean "lotus" or "a couple farming together." The panel to the right of the window reads *ou yuan zhu jia ou*. The panel to the left of the window reads *cheng qin zhu shi cheng*.

Direct translations from the Chinese language into other languages is very difficult due to the nuance of double meanings often embedded in poems and couplets. Among the translations possible with the above couplet are:

> *A loving couple lives in the couple's garden retreat.*
> *A poetic city was built at a corner of the ancient city.*

> *The couple's garden is full of love.*
> *The city is full of literacy.*

Figure 59. The wife, Yan Yonghua, is the author of the carved brick couplet for which the garden is named.

Typically, the author would write the characters in ink and craftsmen would then carefully follow the contours of the calligraphic brush strokes to carve the characters which are then filled with paint, ink, or shiny black coal dust.

ADDRESS

内仓街小新巷5–9号, Neicang Street, Xiaoxin Alley 5–9

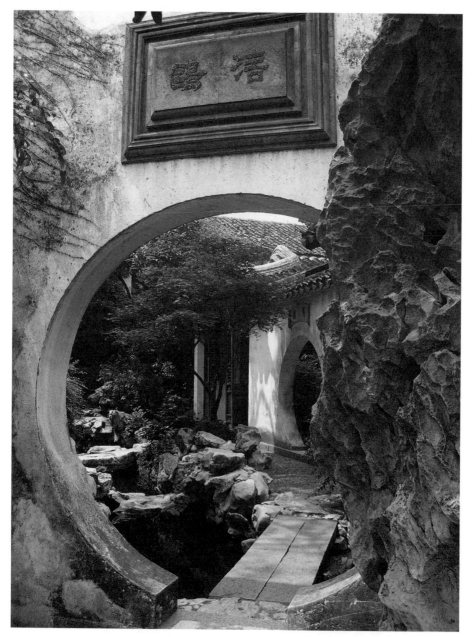

Figure 60. A pair of moon gates lead into the ravine at the Sweet Grass House in the Garden of Cultivation. Only one person at a time passes through a moon gate.

艺圃

YI PU

THE GARDEN OF
CULTIVATION

Yi Pu, the Garden of Cultivation—sometimes referred to as Art Orchard or the Herb Garden—is an important Ming Dynasty garden that has an illustrious family association. It boasts the largest quantity of Ming Dynasty relics of all the gardens in Suzhou.

The garden is located down a narrow alley, Wenya Lane, named after an owner of the garden, Wen Zhenmeng, who was the great-grandson of Wen Zhengming, the famous Ming scholar who painted scenes of the Humble Administrator's Garden. The Ming period is known for elegant, thin proportions in furniture, delicate paintings of garden scenes, and private gardens, such as Yi Pu, that are organized with clearly defined and graciously scaled spaces. A common but simplistic saying goes, "The Tang wrote poems so the Song could have subjects to paint so the Ming would have inspirations to build gardens so the Qing could perform opera and music." Yi Pu is a late Ming garden, so the inspiration from painting has been sufficiently developed, especially among the creative Wen family.

Yi Pu occupies a long, narrow site. The residence and reception halls dominate the northern half of the garden. A pond, rockery, and stream occupy the southern half. The eastern edge contains only a small corridor connecting Wenya Lane to the residence and the western edge contains only a narrow covered walkway connecting the residence to the garden.

MING PAVILION

Visitors enter the residence through a well-preserved Ming pavilion, along a narrow winding corridor lined with mondo grass, hibiscus, and wisteria, and pass through the carved brick gate with the tablet, *Yi Pu*, carved above the brick-faced fireproof doors. In an unusual accommodation to the narrow site, one enters into a corner (rather than the center) of the courtyard of the reception hall built by Wen Zhenmeng, the Shilun Tang. A small opening in the wall of the west corridor grants immediate access to the garden from this reception courtyard and would be the point of entry for guests invited into the garden.

The center of the garden is marked by a lotus pond and the largest waterside pavilion in Suzhou, the five-bay Yanguang Ge, or Longevity Pavilion. The view from the south to the north toward the waterside pavilion is

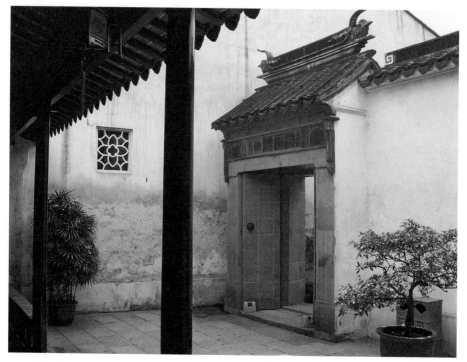

Figure 61. The gate into the courtyard of the Shilun Tang is in an unusual location, in the corner of the courtyard.

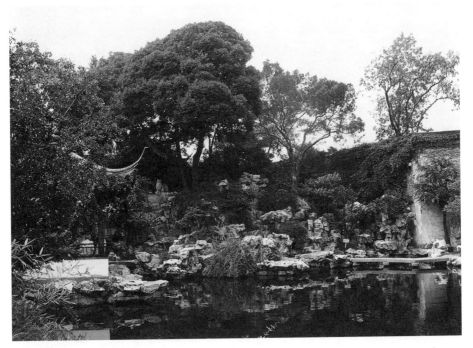

Figure 62. The limestone rockery at the southeast corner of the garden is surmounted by a hexagonal pavilion, the Refreshing Morning Pavilion, sheltered by a large camphor tree. The Breeding Fish Pavilion is at left.

rather monotonous and lacks vitality. Although the water slips under the pavilion, the space seems clogged and the relationship of water to building is not successful.

Behind the Longevity Pavilion is the Nianzu Tang, Hall for Remembering Ancestors, the main hall of the residence where the owner would entertain guests. This hall is also known as Boya Tang, the Hall of Erudition and Elegance. This pavilion is entered from the corners—again an unusual sequence in China—but yet another unique oblique procession in the Garden of Cultivation that is probably a consequence of the narrowness of the property.

The view from the Longevity Pavilion is varied and rich. The limestone rockery ascends above two lower bridges in the southeast. A hexagonal pavilion nestles under the umbrella-shaped canopy of a camphor tree at the pinnacle of the rockery.

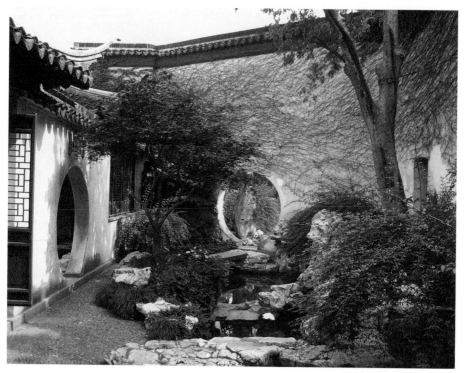

Figure 63. Gates in China are typically obstructed by spirit walls, upright rocks, or plant specimens. A maple tree aligns with the gate leading to the Sweet Grass House, (left) and a limestone specimen is framed by the gate to the lotus pond (center).

THE RAVINE

The southwest vista is marked by an impressive high white wall encrusted with vines. A round moon gate peeks from behind an upright Tai Lake limestone specimen at the water's edge. This gate is the experiential nexus of the garden as it unfolds into the ravine courtyard and the Sweet Grass House. The ground of the ravine slopes down and rocks fall steeply down to the pond. One careens through the ravine. The vitality of this space transforms when one enters the calm, orderly Sweet Grass House courtyard—named after the vetch, *sunchang*, and other grasses planted here. The location of the Sweet Grass House was the former site of the original library.

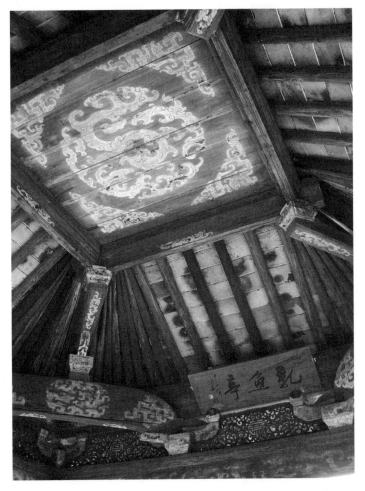

Figure 64. The roof framing of the Ming-era Fish Breeding Pavilion is highly accomplished.

PAUSE AND OBSERVE: PAVILIONS

The Garden of Cultivation is frequented by the neighborhood citizens who will almost always be found sitting in Ruyu Ting, the Fish Breeding Pavilion, a wooden structure with leaning rail seats dating to the Ming Dynasty that rests above the southeast corner of the pond. The ceiling and roof framing of the pavilion are exceptionally accomplished—especially

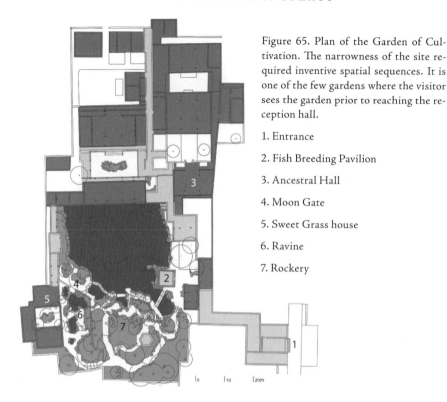

Figure 65. Plan of the Garden of Cultivation. The narrowness of the site required inventive spatial sequences. It is one of the few gardens where the visitor sees the garden prior to reaching the reception hall.

1. Entrance

2. Fish Breeding Pavilion

3. Ancestral Hall

4. Moon Gate

5. Sweet Grass house

6. Ravine

7. Rockery

the corner timbers which cantilever from diagonal beams to support the peak of the roof. The garden is a fine place to begin the day with the early morning sunlight raking across the rockery and the carp competing for the leftovers from last evening's supper. An arcing stone bridge, the Fish Viewing Bridge, spans a small inlet of the pond just southwest of the pavilion and is, indeed, a good place to watch the fish.

ADDRESS

天库前文衙弄5号, Tiankuqian, Wenya Lane 5

Wenya Lane is embedded deeply into the western neighborhood of Suzhou. The lane is very narrow and is inaccessible to vehicles which may make finding the garden challenging.

THE MOUNTAIN VILLA OF EMBRACING BEAUTY

The rockery at the Mountain Villa of Embracing Beauty is widely regarded as the finest in any Chinese garden. The rockery was built by Ge Yuliang (1764–1830), a master of the art of constructing artificial mountains during the reign of the emperor Qianlong. From the *Lu Yuan Conghua* (Miscellaneous Remarks on Lu Garden) by Qian Yun of the Qing Dynasty, we hear about the skill of Ge Yuliang: "Lately, there is a man named Ge Yuliang, a native of Changzhou, whose way of piling a rockery is even better than the others . . . and the rockery in front of the study in the home of Sun Guyuan (Sun Jun) is also piled under his direction."

It is rare that an individual attribution can be made for the design of a garden in Suzhou. Painting and calligraphy are almost always attributable, but the designers of gardens are seen more as skilled artisans and not as authors of works. The rockery in the Mountain Villa of Embracing Beauty is a notable exception.

A MOUNTAIN AT THE CENTER

Unlike most Suzhou gardens, where water lies at the center, the Mountain Villa of Embracing Beauty is centered on Ge's rockery of porous white Tai Lake limestone with its concealed paths, ravines, bridges, and chambers. Limestone is a relatively soft rock which weathers and erodes into smooth

Figure 66. Plans of the Mountain Villa of Embracing Beauty. The plan at left shows the chambers inside the rockery while the one at right shows the garden from above.

1. Rockery 3. Mountain Villa
2. Internal Chambers 4. Putting a Question to the Spring Pavilion

shapes, and Ge exploits these karst characteristics by opening holes and cavities in the rockery. The rockery occupies a proportionately large area of this small garden—about 500 square meters of the total garden area of 2,200 square meters. Holes in the rockery appear as dark recesses from the terrace in front of the artificial mountain, but are sources of sharp southern light in the spaces within the rockery.

Ge Yuliang states the objective of rockery construction: "Only when it is exactly the same as a real hill or cave can one say a good job has been done." Other rockeries by Ge include one in Suzhou—the rockery in the One Pavilion Garden. Outside Suzhou, extant works attributed to Ge include the rockery at Yan Yuan in Changshu, Xiaopan Gu in Yangzhou, and Shuihui Yuan in Rugao.

The spaciousness of the paths and chambers in the rockery distinguish it from others in Suzhou and elsewhere. Access to the rockery is often limited so, if allowed, explore these spaces by entering at the small bridge on the southwest corner. The path leading inside is a narrow shelf at the bot-

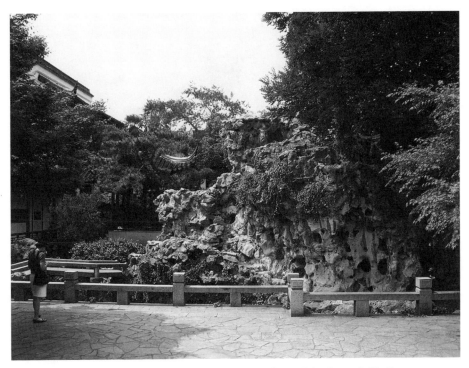

Figure 67. The rockery towers above the terrace in front of the four-sided hall.

tom of the steep face of the rockery which gives it a sense of being caught between the mountain and the stream.

Two diagonal spaces intersect in the center of the rockery. One runs from the Housing the Mountain with a Half-Filled Pool in Autumn Hall in the northwest, along a creek, and upward to the southeast toward the most important specimen tree in the garden, an aged hackberry that casts a contorted shadow on the eastern enclosing wall of the garden. The other diagonal runs roughly southwest to northeast and connects the two internal chambers of the rockery via a stone bridge.

In the reign of Qing emperor Qianlong, the garden was the residence of the scholar Shen Shixing. For two hundred years, the garden was owned, in succession, by Jiang Ji, Bi Yuan, and the scholar Sun Shiyi. The Wang family occupied the garden beginning in the reign of Qing emperor Daoguang (1841). Eight years later, in 1849, the Wang Ancestral Hall and the

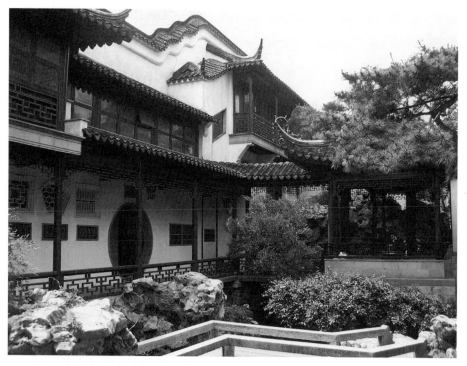

Figure 68. The lively side gallery along the western perimeter of the garden looks over the garden.

Villa for Cultivation were constructed. The East Garden was repaired and the main hall in the garden, located on the terrace south of the rockery, was named the Mountain Villa of Embracing Beauty—the name which was soon applied to the entire garden. The garden was dilapidated by 1949 with only the rockery and Buqiu Fang, Replenishing Autumn Landboat, remaining among the original structures.

The skillful construction of the rockery makes it unnecessary to use plants to conceal or cover parts of it. The trees and shrubs that are used are located north of the rockery. The west side of the garden is dominated by evergreen trees and the east side by deciduous trees. The Housing the Mountain with a Half-Filled Pool in Autumn Pavilion is situated in the northeast corner of the garden among the vibrant fall foliage of maples and hackberry trees. The Make-up Autumn Gallery is the largest of the pavilions north of the rockery. Adjacent to it and connected by corridors is

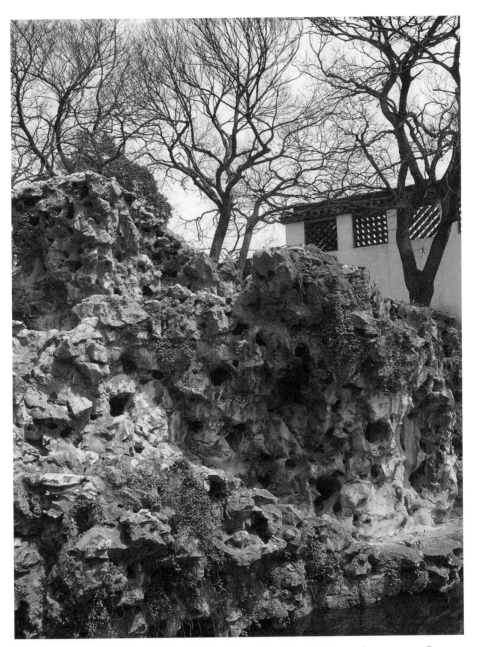

Figure 69. The porous texture of the rockery is exploited by the rockery master, Ge Yuliang.

the Putting a Question to the Spring Pavilion, which is placed on a small island between the major rockery and the small and notable rockery in the northwest corner.

PAUSE AND OBSERVE: ROCKERIES

Sit on the terrace overlooking the rockery and observe the artistry of this formation. Layers of rocks just behind the water conceal the path immediately behind it. The porosity of the center section reveals the presence of one of the largest chambers immediately behind it—yet occupants of the rockery space remain obscured from the terrace.

The rockery was constructed using sticky, glutinous rice as a setting bed with periodic iron straps to secure structurally significant stones.

ADDRESS

景德路262号 Jingde Road 262

The Mountain Villa of Embracing Beauty is located inside the Suzhou Silk Embroidery Museum.

THE MOUNTAIN VILLA OF EMBRACING EMERALD

The Mountain Villa of Embracing Emerald, sometimes called the Mountain Villa of Luxuriant Verdure, is located inside the Tiger Hill Pagoda complex northwest of the old city. Located on a steep slope, the garden exploits the liveliness of ascending a series of four terraced courtyards.

As one crosses the Surging Waves Bridge and begins to ascend the slope of the Tiger Hill, a flight of steps just west of the main path leads to a black-framed gate and a small series of pavilions and courtyards. This is the Mountain Villa.

TERRACED GARDEN

Whereas the other gardens of Suzhou are situated in the flat watery plain, the four terraces and courtyards of the Mountain Villa scramble up a rocky hill, and the quirky adjustments to the topography lend a great deal of variety and interest to the complex. The south and north courtyards are symmetrical in keeping with the prevalent Chinese traditions; however, the middle courtyards wind their way up the hill and are particularly fine.

The imposing black gate of the villa commands the top of a steep flight of steps. One enters a very small forecourt and almost immediately into the largest hall of the garden, the three-room wide Holding the Jar Hall.

Figure 70. Plan of the Mountain Villa of
Embracing Emerald

1. Gate
2. Han Han Spring
3. Entrance stair and gate
4. Scholar's Retreat Among the Clouds
5. Looking toward Cloud Crag Pagoda

Just below and outside the eastern wall of
the courtyard is the Han Han Spring.

Behind the hall is a hillside courtyard
divided into two by a stone wall. A winding
stair, which deflects around a pavilion, con-
nects the two terraces. The tree canopy and
stands of bamboo embrace the visitor in the
lofty prospect of the upper terrace. Lacebark pines,
sweet-scented oleander, and crepe myrtles in the gar-
den merge with the forested hillside and provide a sense
of being among the woods of the forest.

LANDSCAPE OF ROOFS

The roofs of the various pavilions exert a strong visual presence, making
this a good place to observe the craftsmanship of the dark gray Suzhou
roof tiles. The stone walls, stairs, and courtyard pavements are also notable
for their robust scale, weathered finish, and rural coarseness.

The uppermost courtyard deftly negotiates the sloping terrain with a
central set of steps that ascend to the upper terrace of the last hall, the
Scholars' Retreat Among the Clouds. Supplementary stairs tuck under el-
egantly sloping roofs of the perimeter corridors. Note how the outermost
roof follows the level courtyards, while the innermost roof slopes in con-
formance with the hillside.

The Mountain Villa of Embracing Emerald is just one place of interest

Figure 71. A long stair leads to a black gate at the entrance to the Mountain Villa.

on this richly historic hill, the site where the King of Wu buried his father. Three days after the burial, a white tiger was observed crouching on the tomb, hence the name Tiger Hill. The Wang brothers of the Eastern Jin Dynasty built a villa here which was later converted into the Tiger Hill Monastery, which endures.

Figure 72. Terraces and courtyards on the hillside.

CLOUD CRAG PAGODA

The summit of Tiger Hill is surmounted by a seven-story octagonal brick pagoda, the Huqui or Cloud Crag Pagoda, which was built around 960. The pagoda leans noticeably to the northeast and is more than two hundred years older than the other famous leaning tower in Pisa, Italy.

Figure 73. On the upper terraces, the tree canopy envelops the graceful gray tile roofs of the pavilions.

PAUSE AND OBSERVE: STONE MASONRY

The Mountain Villa is a catalog of steps and stairways, many of which are cleverly concealed or which lead to unexpected destinations. One such stairway slips out the east side of the lower courtyard to a two-story pavilion that perches above the main path leading to the pagoda at the top of Tiger Hill. Musical performances are often under way in the pavilion.

Another set of steps in the uppermost courtyard is hidden in the corridor surrounding the courtyard. These stairs bypass the terrace in front of the pavilion and enter the pavilion from the side. They add variety to what might otherwise be a singular path through the pavilions and courtyards of the villa. The stairs delineate paths with varied points of departure and destinations.

Figure 74. The garden is a series of courtyards that ascend the hillside. One roofline follows the sloping ground and the other parallels the level courtyard.

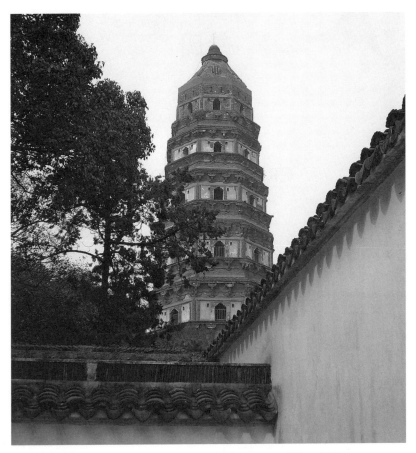

Figure 75. The Cloud Crag Pagoda commands the summit of Tiger Hill.

ADDRESS

山塘街虎丘山门内8号, Shantang Street, Huqiu Shanmennei 8

Enter the Tiger Hill complex, cross the Surging Waves Bridge, and pass through the Broken Beam Hall. The stairs that lead to the black gate of the Mountain Villa are west (left) of the Hall.

鶴園

HE YUAN

CRANE GARDEN

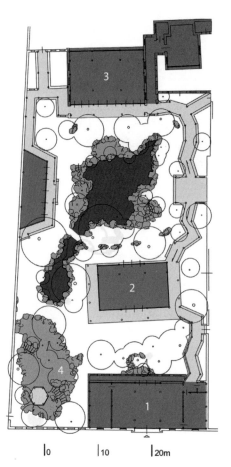

The Crane Garden is a small Qing garden with a tortuous winding corridor that wraps around the eastern and northwestern perimeter of the garden.

The garden is entered through the northeast corner of the entry hall, a five-bay hall with whitewashed walls that obscure immediate views into the garden. The corridor then winds up and down and in and out along the eastern side of the garden. Finely scaled spaces are created between the corridor and the high whitewashed eastern wall. During late afternoon, the low sun casts orange-tinted shadows of bamboo on the wall.

Figure 76. Plan of the Crane Garden

1. Entrance
2. Four-sided pavilion
3. Main hall
4. Rockery

The corridor connects to the veranda of a four-sided hall in the center of the garden. This hall divides the garden into two parts: the southern half includes the entry hall and a rockery in the southwestern corner; the northern half centers around a small pond.

A pavilion with soaring, uplifted eaves faces west across the pond, a three-bay hall anchors the northern end of the garden, and another small pavilion looks east across the pond and provides a view to the winding corridor that is the best attribute of this garden.

The garden is west of the main residence and was built by Hong Luting during the reigns of Emperors Guangxu and Xuantong of the late Qing Dynasty. A visit to the garden may require local assistance as it is often closed.

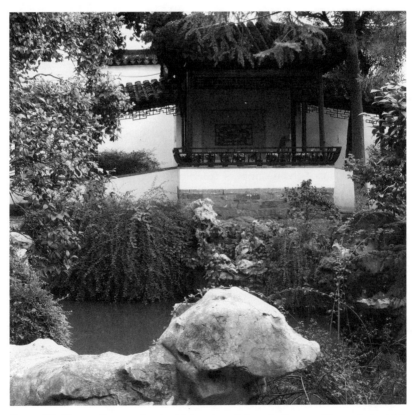

Figure 77. The pavilion marks the high point of the winding corridor and sits high above the deep pond.

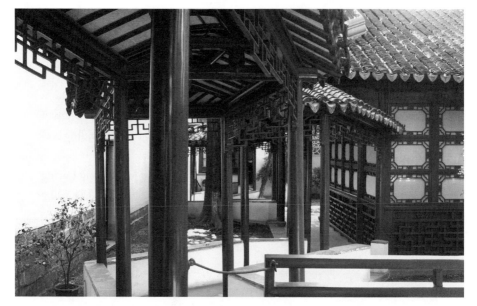

Figure 78. The winding corridor meanders through a thicket of columns.

PAUSE AND OBSERVE: WHITE WALLS

Suzhou is a city of tall white walls and charcoal gray roofs. Verdant dark green pines, dusty green camphor trees, and bright green bamboo lightly wash across this reserved color palette. With the setting sun, however, the white walls of Suzhou become vividly tinted with pink and orange.

Many of the gardens capitalize on this spectacular quality of light by building high white walls on the eastern side which can collect the watercolor hues of the setting sun into the garden. Shadows of bamboo and other plants are also written on the walls with the subtle tonality of an ink-brush painting. A visit to Suzhou must include watching a lingering sunset across one of these garden walls.

ADDRESS

韩家巷4号, Hanjia Alley 4

ZIGZAG GARDEN

Qu Yuan, also known as the Zigzag Garden or the Former Residence of Yu Yue (noted as such on the plaque at the door), is a modest garden distinguished by a pair of half pavilions that face each other across a deep rectangular pool. The long, narrow garden is enclosed by high white walls that compress the space but also deflect beautiful light into the garden. Its interest is that it is highly representative of modest gardens, few of which are accessible to visitors.

Constructed in the late Qing Dynasty, the garden is most noted for the fame of its residents, the Qing scholar Yu Yue and his even more well-known grandson, Yu Pingbo, who was known for his scholarship on the Chinese classic *Story of the Stone*, or *The Dream of the Red Chamber*. The name of the garden, Zigzag Garden, comes from the Daoist master Laozi, "tortuous then straight, down then up." The sentiment in the saying is not just about space but also about human emotions and relationships.

The garden was severely damaged in the Cultural Revolution and rebuilt in 1982.

PAUSE AND OBSERVE: *THE DREAM OF THE RED CHAMBER*

The garden is perhaps more famous by association than for the quality of the garden itself. The classic Chinese novel *The Story of the Stone*, written

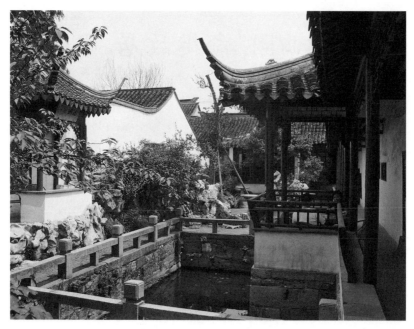

Figure 79. The deep water basin is flanked by two half-pavilions in the Zigzag Garden.

in the mid-1700s, provides one of the most vivid literary chronicles of life in the gardens during the Qing Dynasty. Much of the story takes place in the fictional Prospect Garden, built to celebrate the selection of a member of the family as an imperial concubine.

The novel is a complex work of literature, having been written over a long period of time. Its authorship is similarly complex as it has, like the gardens themselves, been added to and amended over time.

Two sites in Suzhou have important relationships with this novel. The primary author, Cao Xueqin, spent part of his boyhood at the Humble Administrator's Garden, which was owned by a relative. The second site of significance for the novel is the Zigzag Garden, the family residence of the eminent critic and scholar of the novel, Yu Pingbo.

ADDRESS

人民路马医科43号, Renmin Road, Mayike 43

CAREFREE GARDEN

The Carefree Garden is the best of the very small gardens in Suzhou. The long, narrow space barely accommodates all the elements of the garden: pond, bridge, corridors, terrace, pavilions, halls, hills, rocks, trees, and shrubs.

The garden, which lies east of the residence, is entered from the southeast and is best experienced as a counterclockwise circumnavigation of the pond: first along a covered corridor along the east wall, across a small terrace between a hall and the pond, through a hall on the west, and finally a corridor climbing atop a rockery in the southwest corner where a commanding view of the garden you have just walked through is provided.

LONG DIAGONAL VIEWS ACROSS THE POND

The pond is always near, and the primary sightlines exploit the longer views so that the water fills the scene. The entry pavilion, the rest pavilion, the main hall, and the Waiting for the Moon Pavilion are all located at the corners or end of the garden so that the views from a seated position are extensive. The east and west sides of the gardens, on the other hand, are places of movement or internalization: a winding corridor on the east and the Washing My Dusty Clothes Pavilion on the west, the latter which

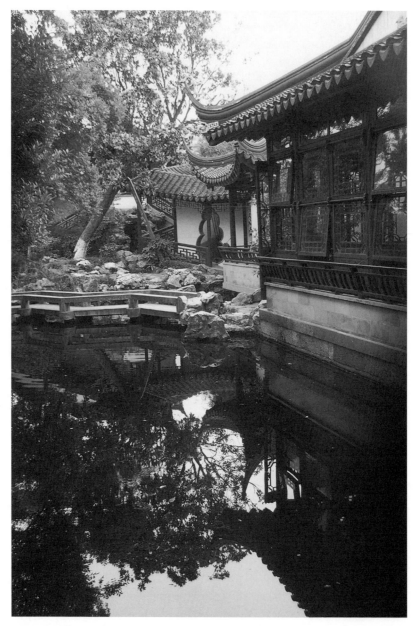

Figure 80. The southwest corner of the Carefree Garden includes a gourd-shaped gate leading to a pavilion atop a small rockery. The large leaning tree reflected in the pond is a *Magnolia grandiflora*, a North American species that is common in the gardens.

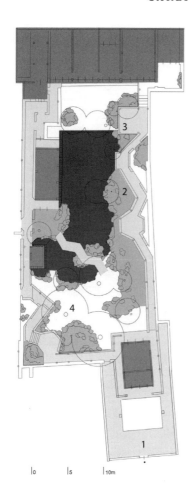

Figure 81. Plan of the Carefree Garden

1. Entrance
2. Winding corridor
3. Waiting for the Moon Pavilion
4. *Magnolia grandiflora*, southern magnolia

awkwardly retains the pond, rather than cantilevering over it.

Among the trees in the garden is a large *Magnolia grandiflora*, an American tree, planted in the southwest corner. Much has been written and studied about the plant hunters from Europe and the Americas who collected plants from Asia for botanical and horticultural interest, but few recognize that the Chinese were also inveterate collectors of exotic specimens from the west.

PAUSE AND OBSERVE: GARDEN CORRIDORS

The eastern wall of the Carefree Garden is defined by a long, winding corridor. The purpose of such corridors is rather simple: they provide shelter during the frequent rains so that the garden can be used and enjoyed in rain (or infrequent snow). One can almost imagine that these gardens reach their peak with a light spring rain creating an active and sonorous pond surface.

The garden corridors are punctuated by pavilions and overlooks, such as here at the Carefree Garden, which has two such places. Nearest the entrance is a six-sided pavilion that surmounts a high point along the corridor. The second is a small overlook that dips down to almost touch the

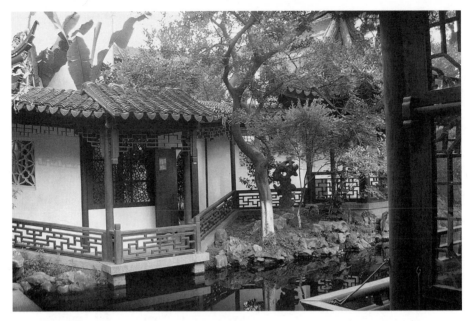

Figure 82. The corridor descends to a small overlook that places the visitor in direct contact with the active surface of the water.

surface of the water. As one descends to this overlook, the eyes are cast down and the water envelops the view. The reflections in the water, the fish that await the visitors, or the raindrops that disturb the quiet surface of the pond all become amplified, vital experiences.

These surging waves of corridors create compact experiences of ascent and descent. Most of the corridors also bend away from each other or from walls to which they are attached to create small courtyards often populated with upright jade stones and bamboo—small living sketches.

ADDRESS

庙堂街庙堂巷22号, Miaotang Street, Miaotang Alley 22

Gardens
Near
Suzhou

退思园
TUISI YUAN

GARDEN OF RETREAT AND REFLECTION

The Garden of Retreat and Reflection, sometimes referred to as the Garden of Meditation, is located in the canal village of Tongli, about twenty kilometers southeast of Suzhou. Although it is the youngest garden included in the guide, built in 1885 during the last decades of the Qing Dynasty, it is renowned for the highly successful relationship between the pond and the surrounding buildings (see Pause and Observe).

Ren Lansheng, a government official, built the garden and named it after a passage in the classical Chinese volume Zuozhuan, "working to dedicate myself to my country, and retreating to meditate on mending my ways." Jiang Kui, a Southern Song poet, is the source of many of the named views in the garden.

ENTERING THE GARDEN

The outer precinct contains six courtyards, each with its own gate and two-story residences. Entry to the garden is made from a garden courtyard with a boat-shaped pavilion into the western side of the pond where a small pavilion immediately brings one out over the water.

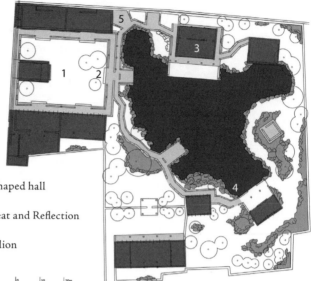

Figure 83. Plan of the
Garden of Cultivation
and Reflection

1. Courtyard with boat-shaped hall
2. Entrance
3. Thatched Hall of Retreat and Reflection
4. Heavenly Bridge
5. Gathering Beauty Pavilion

THE THATCHED HALL OF RETREAT AND REFLECTION

Walk clockwise around the pond to the main building of the garden, a south-facing hall overlooking the pond. Although called Tuisi Cottage, the Thatched Hall of Retreat and Reflection, it does not have a thatched roof and its elegant proportions and scale belie its humble moniker. As you stand on the stone terrace of the hall and scan the garden from right to left like a scroll painting, your gaze will take you from a small waterside pavilion where you entered the garden to a boat-shaped pavilion "docked" on the pond's edge, a two-story hall, a flying bridge partly concealed by a columnar rock formation, a one-story cottage, and a rockery mountain. A walk around the garden will take you on a metaphorical journey across the water into the mountains.

HEAVENLY PROSPECTS

Heavenly Bridge, a double-sided flying bridge on the south side of the pond, climbs over the small Xin Terrace (with its collection of Tai Lake

limestone rocks) to provide a lofty prospect over the garden. Looking out from the bridge toward the deep northwest corner, one can see a second ideal place to survey the garden from above—the small Gathering Beauty Pavilion.

PAUSE AND OBSERVE: PONDS

The Garden of Retreat and Reflection is generally recognized for the way that the pavilions in the garden sit in very close proximity to, or seem to float over, the pond. A second layer of smaller studios or corridors are positioned further away and above the water to provide views down and across the pond.

A comparison of the pond and pavilion relationship at Tuisi Yuan and that of Wangshi Yuan, the Garden of the Master of the Nets, is useful. At the Garden of Retreat and Reflection, the pavilions are low and, in the words of the Chinese garden scholar Chen Congzhou, "nestle among the waters." The pavilions project out into, float just above, or sit in low repose alongside the pond. At the Master of the Nets Garden, which has a similarly sized pond, the pavilions are more remote from the water and reside high above the pond—and there are no lofty perches to scan over the garden from above.

Most ponds in the Suzhou gardens have a remarkably consistent square or rectangular shape. Corners are stretched and pulled to suggest water sources or streams—and in most instances to connect to the water from adjacent canals. These streams often appear to have a source in the northwest and an outlet in the southeast in accordance with feng shui beliefs.

One of the few other late Qing gardens of high merit is Guozhuang Villa on the shore of West Lake, Xihu, in Hangzhou. The villa is centered around gardens on two ponds. The south garden is compact, dense, and lively. The north garden is a spare proto-modern water garden with horizontal lines, a superb zigzag bridge, and well-selected plant specimens.

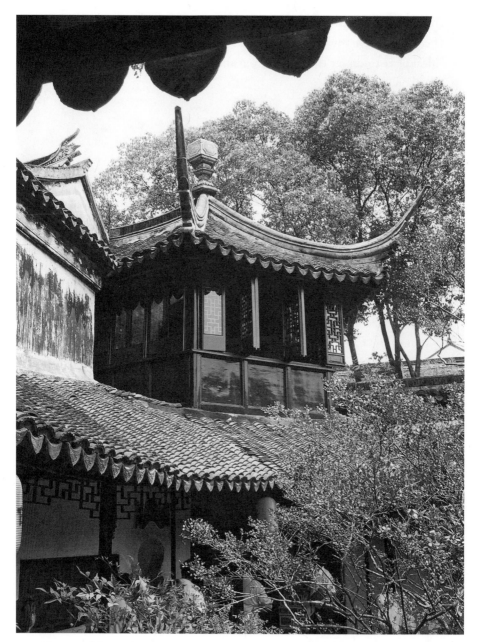

Figure 84. The Gathering Beauty Pavilion in the northwest corner of the garden provides a prospect from which to view the entire garden.

ADDRESS

吴江市同里镇新镇街, Xinzhen Street, Tongli Town, Wujiang

Tongli can be reached in several ways, but an adventurous traveler will go via boat on the Grand Canal. Boats depart from near the Suzhou north railroad station and the boat ride is an hour-and-a-half immersion into contemporary life on the Grand Canal with close views of the graceful 1,200 year-old Tang Dynasty Precious Belt Bridge, Bao Dai Qiao, and the still heavily traveled industrial waterway. Buses also leave from the Suzhou South Bus Station. Group tours are also available by bus and boat from Shanghai and Suzhou to Tongli and the adjacent water village, Zhou-zhuang.

A stroll through Tongli may prove rewarding, as it contains a respected collection of classical Chinese buildings that line the streams and canals that wind through the village.

Tongli is also the birthplace of Ji Cheng, the author and editor of *Yuan Ye*, or, *The Craft of Gardens*, a treatise on the theory and practice of gardens compiled in 1631 at the end of the Ming Dynasty. This treatise systematized horticultural and garden writing at a time when garden culture was flourishing in China. Ji's former residence is open to the public, as are several other former residences and family halls. Some of the latter, such as the Pearl Pagoda, include gardens—although far inferior to the important Garden of Retreat and Reflection.

寄畅园

JICHANG YUAN

GARDEN OF THE
PEACEFUL MIND

Jichang Yuan was visited and deeply admired by the Qing Emperors Kangxi and Qianlong which led to its great influence on imperial gardens in Beijing and the summer palace at Chengde. It is sometimes referred to as Qin Yuan 秦园 and is located in Wuxi, a large city on the banks of Tai Lake approximately sixty kilometers west of Suzhou.

The garden is arranged around a long, slender lake surrounded by neighboring hills to the north and west. The reflection of the hills in the still water of the lake lends depth and expanse to the garden.

BORROWED SCENERY

Jichang Yuan is notable for its borrowed scenery (see Pause and Observe) where two hills outside the garden, Huishan and Xishan, are incorporated into garden views.

It was first laid out as a Buddhist monastery garden in the Yuan Dynasty, a heritage it shares with Suzhou's Lion Grove. In the Ming Dynasty, it was owned by the influential naval minister Qin Liang, who created a private garden in 1591 and named it Jichang Yuan, after an essay by the calligrapher Wang Xishi (303–361).

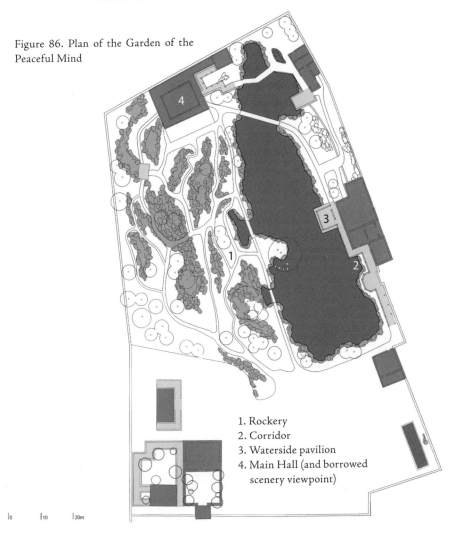

Figure 86. Plan of the Garden of the
Peaceful Mind

1. Rockery
2. Corridor
3. Waterside pavilion
4. Main Hall (and borrowed
 scenery viewpoint)

IMPERIAL INSPECTIONS OF THE SOUTH

The garden was remodeled and extended in the Qing Dynasty and both
the Kangxi emperor and his grandson, emperor Qianlong, visited the gar-
den on their southern tours. It was the first garden visited by Qianlong
in 1751 on the first of his four "inspections" of the South. The Garden of
Harmonious Interests, Xiequ Yuan, in the northeast corner of Yihe Yuan,

the Summer Palace in Beijing, was built by Qianlong based on Jichang Yuan three years after his first visit, in 1754.

A LINEAR GARDEN

A long pond stretches roughly north-south through the garden. On the west side of the pond is a series of manmade hills with a variety of paths winding among them. This rockery is significantly less dense and compact than those in the city gardens of Suzhou. On the east side, a series of pavilions are squeezed between the pond and a tall white wall to which many of the pavilions are attached. At the center of the pond, a tree on a small peninsula leans over to a companion tree sheltering a small pavilion on the other side and pinches the space of the garden in the middle.

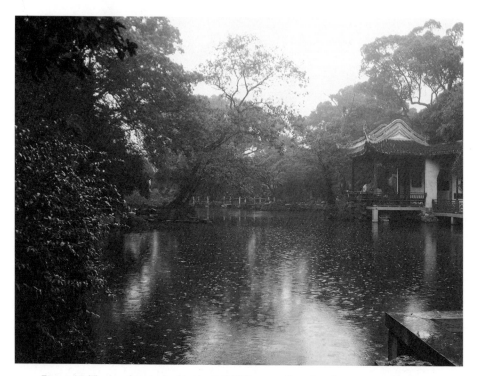

Figure 87. The pond is pinched in the middle by a small peninsula punctuated by a tree leaning over the narrow waterway opposite a sitting pavilion.

The garden is strung out along this north-south line, a device which adds to the spatial expansion of the garden and also opens the garden to views of the nearby hills.

THE NORTH END

At the north end of the pond is the main hall which, in an unusual configuration, obliquely addresses the pond and more directly faces the interesting path along the foot of the hill. In the northeast corner, a pair of bridges frame smaller pools of water around which a small pavilion, corridors, and several terraces are gathered.

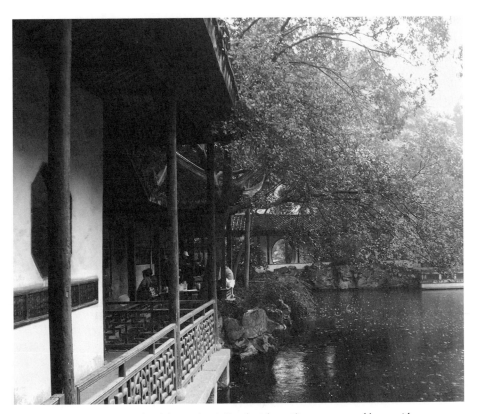

Figure 88. The east side of the garden is lined with pavilions connected by corridors.

DESTRUCTION OF THE GARDEN

Jichang Yuan was burned to the ground in 1860 during the Taiping Rebellion. Ironically, in the same year Anglo-French troops in Beijing looted and destroyed the imperial gardens—including the replica garden that Qianlong had built. It was a time of irreplaceable destruction of garden and cultural heritage in China.

Many of the buildings in the southern part of Jichang Yuan were never rebuilt, but the central garden has recovered much of its former configuration. In Beijing, the replica garden, in the northeast corner of the Summer Palace, was restored in 1893 for the Empress Dowager Cixi and can now be visited.

PAUSE AND OBSERVE: BORROWED SCENERY

Borrowed scenery, opening views to significant landscapes or structures outside the boundary of gardens, is a well-practiced strategy in the Suzhou gardens. At the Humble Administrator's Garden, a long view from the eastern end of the pond is directed to the North Pagoda just outside the garden. At the Lingering Garden, a pavilion in the western section formerly provided a view to the pagoda at Tiger Hill.

At Jichang Yuan, the borrowed views are to the hills and pagoda of Huishan surrounding the garden. In gardens such as the Lion Grove or the Mountain Villa of Embracing Beauty, hills and mountains had to be constructed. At Jichang Yuan, the views to the atmospheric, shapely mountains simply had to be opened up with long vistas across an elongated body of water.

ADDRESS

无锡市惠山东麓惠山横街, Huishanheng Street, Huishandonglu, Wuxi

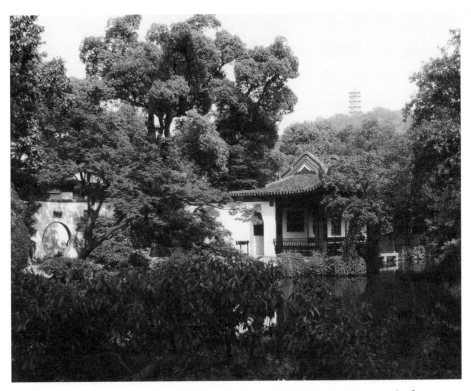

Figure 89. The celebrated view of the pagoda atop Hui Mountain is among the finest examples of borrowed scenery.

Jichang Yuan is in Wuxi, a large city accessible by train, bus, or hired driver from Suzhou or Shanghai. The garden is located in Huishan Park and the central garden is not easy to find among all the chrysanthemum dragons and boxwood pagodas that decorate much of the park. As fantastic as these horticultural spectacles may be, keep moving because the historic garden will provide even greater reward.

GARDEN OF PEACE
AND COMFORT

The Garden of Peace and Comfort in Shanghai, eighty-five kilometers from Suzhou, is among the largest of the scholar gardens. The large yellow stone rockery and brick carving of the dragon walls and roof figures are exemplary.

Yu Yuan, unlike most gardens where earthen hills and rockeries divide the landscape scenes, is compartmentalized into dozens of small "space-cells," as Maggie Keswick refers to them, by tall white walls capped with black tiles.

Pan En and his son, Pan Yunduan, began the garden during the Ming Dynasty reign of Emperor Jiajing (1559), when Shanghai was just a small coastal village. The garden was severely damaged when it was occupied by troops during the Taiping Rebellion in 1861, and the garden that is visible today is largely rebuilt since the 1950s.

The approach to the garden is across a zigzag bridge crossing a small pond with a teahouse, which was formerly part of the garden and a purported model for the pavilion on the blue willow pattern of porcelain. The entrance is off the forecourt at the end of the bridge.

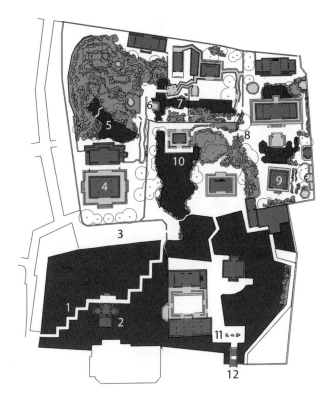

Figure 90. Plan of the Garden of Peace and Comfort

Outer Garden
 1. Fifteen Zigzag Bridge
 2. Teahouse
 3. Entrance

Rockery Area
 4. Three Ears of Corn Hall
 5. Rockery

Stream Area
 6. Waterside Pavilion for Viewing
 Happy Fish

7. Stream
8. Dragonhead wall
9. Spring Hall

View Gathering Area
10. View Gathering Hall
11. Exquisite Jade Peak
12. Gate to Inner Garden

HALL OF ABUNDANCE

The spacious and dignified Sansui Hall, or Three Ears of Corn Hall, lies just inside the gate. Rice, wheat, corn, and fruit are carved on the wooden beams and frames to signify abundance and prosperity. A small rear

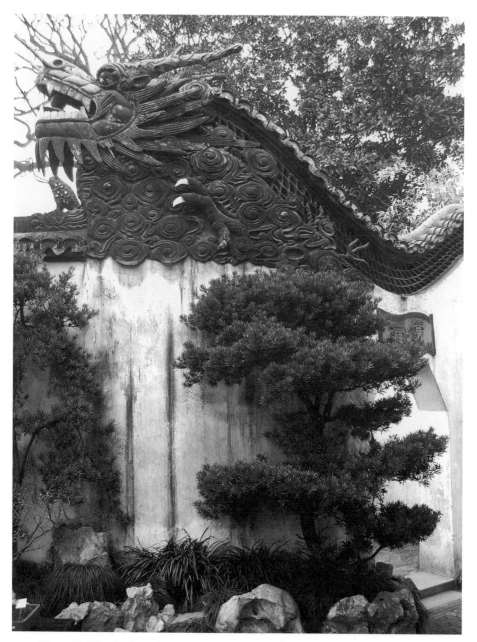

Figure 91. The Garden of Peace and Comfort is divided into distinct spaces by tile-capped walls, including this one that terminates in a dragonhead.

corridor is framed at each end by vase-shaped gates, the first of many shapely gates in the garden.

Behind the hall is a two-story pavilion with exuberant flying eaves that is perched high over a pond and looks toward the rockery to the north.

YELLOW STONE ROCKERY

The rockery, which is piled over forty feet tall, was built by the Ming Dynasty master, Zhang Nanyang, and is his only surviving work. The rockery steps back rather than pushes forward as many do. Near the summit is a pavilion from which there was once a panoramic view across Shanghai and boats on the Huangpu River.

THE SMALL STREAM

East of the rockery is a compact, dense, and fascinating complex of spaces with a double corridor, several pavilions, and a pair of old trees in a courtyard arranged along a small stream (see Pause and Observe). A short bridge crosses the stream, but before entering the double corridor, be sure to turn south to the Yule Pavilion, or the Waterside Pavilion for Viewing Happy Fish. From here one can see the stream crawl under an arch at the bottom of a wall decorated with a carved window.

The double corridor—a train-wreck-like series of short segments— bends sharply and is pierced by windows that force views from one side of the corridor to the other. One can careen through one side of this faceted passage, turn around, and continue to capture montage-like glimpses of rocks, then water, then other people, then the rail of a porch, then the leaf of a banana plant, and on and on.

Stumbling out of the corridor, one arrives in a calm, intimate courtyard in front of Wanhua (Ten Thousand Flower) Hall. The courtyard is dominated by two trees protected by marble balustrades: a four-hundred-year-old ginkgo tree that was planted in the Ming Dynasty and a magnolia tree that is more than two hundred years old. The courtyard overlooks the

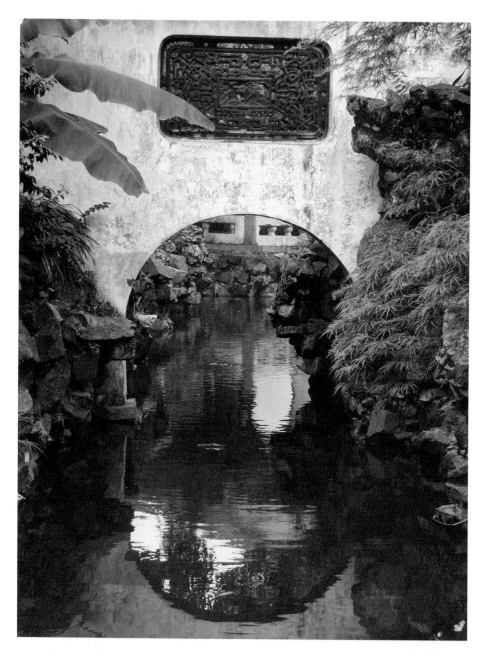

Figure 92. Banana plants enliven the west end of the stream. Rainwater bounces off the glossy surface of the subtropical plants and into the deep water of the ravine with sharp, resonant tapping. In clearer weather, bright sunlight penetrates the thin membranes of the large, bright green leaves to reflect onto the still water of the stream.

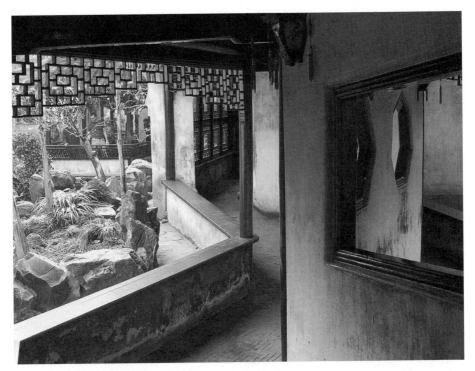

Figure 93. A double corridor careens through the garden.

narrow stream to a rockery pressed up against the wall on the opposite bank. To the east is a small winding corridor and a glimpse to a black tile dragonhead, one of several that surmount walls in the garden.

SPRING HALL AREA

East of this area and on the other side of the dragon wall is an area with four pavilions separated by two ponds. The two northern halls are bright, spacious, and rest close to the ground. The southern ones, which include a small performance stage, are sited off the ground and merge with a tall rockery along the eastern edge of the garden from which views over the city can be enjoyed.

The main hall of this area, Dianchun (Spring) Hall, was a headquarters

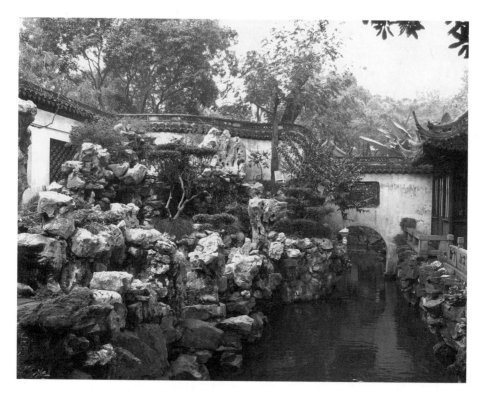

Figure 94. The eastern side of the stream is flanked by a courtyard with a pair of important trees and a rockery.

of the army of the Taiping Rebellion, and artifacts from that period are on display here. The hall looks south to the stage and, toward the west, to a better view of the superbly crafted dragon head. Begin to look skyward to the roofs and wall caps in this and subsequent areas for an exuberant menagerie of carved black cranes, immortals on horseback, dragons, phoenixes, and other allegorical figures. In early spring, this area is also filled with potted *penjing* and *penzai* of flowering peaches and plums.

VIEW GATHERING HALL AREA

Walk out the southwest corner of this area under a gate, with two dragons playing with a pearl, into the eastern section of the garden. The scale im-

mediately shifts to detached pavilions scattered about a vast pond crossed by bridges and framed by a stand of dawn redwood trees and a grove of bamboo. The pond bends around the Huijing (View Gathering) Tower at the center of the garden as the pond stretches from the northwest to the southeast.

EXQUISITE JADE PEAK

The focus of halls and corridors in the southern end of the pond is directed toward the Exquisite Jade Peak, a famous specimen stone that was probably collected as early as the Song Dynasty. The setting for this stone, however, is poor. A background wall cuts across the stone at its waist, and the view to the stone is from the north, which means it is usually seen backlit by the sun.

The garden builder Pan Yunduan constructed his study to look toward the stone, arguably the most important historic artifact in the garden and the one that the owner reserved for his own enjoyment by placing it at the end of the garden sequence. To the west of the stone is an enclosed courtyard with a pair of two-story halls, the southernmost one being a library. The buildings overlook the pond and teahouse at the entry to the garden to the west. To the east of the stone is the Hanbi Tower, which is also known as Nanmu Hall because of its construction with the rare southeast Asian wood *Phoebe nanmu*.

NEI YUAN 内园 INNER GARDEN

Beyond the Exquisite Jade Peak is a Qing Dynasty garden built in 1709, Nei Yuan, or Inner Garden, that has now been incorporated into the greater Yu Yuan. A large hall overlooks a menagerie of rocks in the northern half of the garden. To the south, a tall three-story building looms over a courtyard organized with spectator galleries and a large performance stage, the ceiling of which is carved like a great vortex rising above the stage.

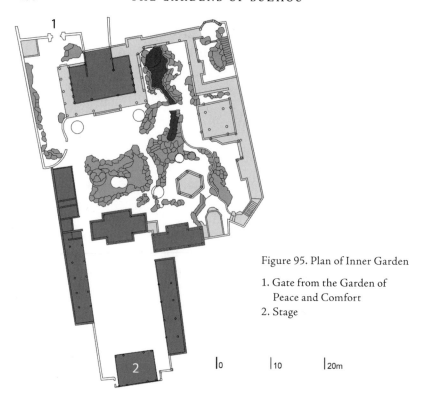

Figure 95. Plan of Inner Garden

1. Gate from the Garden of
 Peace and Comfort
2. Stage

|0 |10 |20m

PAUSE AND OBSERVE: STREAMS

The land around Suzhou is criss-crossed with shallow streams and canals as well as the important larger water bodies such as Tai Lake. In the gardens, the larger ponds are usually at the center, but many smaller streams and rivulets add vitality to the experience of water in the gardens.

These streams link larger ponds, as with the case with Yu Yuan, or serve as the conduits through which water is channeled from canals into the garden. The stream in the Garden of Peace and Comfort is only 150 feet long, but it is a highlight of the garden.

ADDRESS

上海市黄浦区安仁街137号, Anren 137, Huangpu District, Shanghai

The garden is surrounded by markets, a temple, and some very good food vendors. Just outside the garden, where the long line of people will inevitably be, is Nanxiang Mantou Dian, a popular seller of dumplings. Nanxiang is a village northeast of Shanghai, and true Nanxiang dumplings can be enjoyed in a less frenetic setting by visiting the Garden of Ancient Splendor, the garden described next.

古漪园
GUYI YUAN

GARDEN OF ANCIENT
SPLENDOR

Guyi Yuan is located in the village of Nanxiang approximately twenty-one kilometers north of Shanghai and is accessible via the municipal bus system or hired taxi. Among other attributes, the restaurant at the south gate of the garden is renowned for its *xiaolongbao*, and a visit to the garden would be incomplete without a lunch of these prized local dumplings.

PARK ATMOSPHERE

The garden was originally one-fifteenth of its current size, and the growth of the garden has transformed it into a landscape that seems more like a public park than a private garden. The remoteness of Guyi Yuan from tourist centers also contributes to the garden being used more as a public park full of residents picnicking, boating, exercising, and flying kites.

The garden was built in the mid-1500s during the Ming Dynasty and was originally named Yi Garden for the scenic views of bamboo, by the bamboo-carving master Zhu Shansong. The garden was renamed Guyi Garden after it was rebuilt in 1746.

Visitors can enter the garden from the southwest corner near the dumpling restaurant and stroll clockwise around the western end of the large lake that stretches east-west across the garden. One can also enter in the northwest corner.

Figure 96. Plan of Garden of Ancient Splendor

1. North Gate
2. South Gate and *xiaolongbao* dumpling restaurant
3. South Hall
4. Floating Bamboo Pavilion
5. Tang Dynasty stele

At the western end of the lake is a fine view, with the waterside South Hall overlooking the lake and the six-sided pavilion in the center of the distant Nine-Zigzag Bridge.

VIEWING HAWKS AND FISH PAVILION

The historic core of the garden is in the northwest corner of the current garden where small interconnected ponds are linked by bridges and bisected by causeways. Overlooking the western pond is Viewing Hawks and Fish Pavilion, a half-wall, half-porch mélange of moon gates, carved windows, and leaning balustrades all covered by a flying eave roof.

Figure 97. The South Hall overlooks the central lake.

SOUTH HALL

Walk counterclockwise around the pond toward the South Hall, whose commanding carved brick gate is nestled among a thriving grove of bamboo that alludes to the original Ming garden's renowned bamboo collection.

FLOATING BAMBOO PAVILION

The small eastern pond includes the finest pavilion in the garden, the Floating Bamboo Pavilion, which faces a boat-shaped pavilion across the shallow pond. The Floating Bamboo Pavilion appears almost tethered to the shore of the pond, and the refined way the pavilion meets the water makes it appear as if it could just float away.

Figure 98. A gardener plies the water to perform routine maintenance in the garden.

TANG DYNASTY STONE PILLAR

To the northeast, across the stream from the stone boat, is a small open court with an especially beautiful carved stone pillar that dates from the Tang Dynasty. Stylized lotus leaves are tightly closed at the bottom and, as they are carved in several stages up the pillar, become more and more open. At the top, the leaves burst open and the pillar is topped by a tightly closed blossom.

PLUM BLOSSOM HALL

Walking south from the pillar is the Plum Blossom Hall, where windng corridors and equally winding streams meander around a grove of plums

Figure 99. The Floating Bamboo Pavilion hovers just above the surface of the pond.

blossoms (see Pause and Observe). The modern informational tablet at the hall declares that "when the plum blossoms are in full bloom in Spring, one will find a wonderland here when walking."

THE GARDEN AS A PARK

From here, the garden begins to break down and the contemporary extension of the garden into a park overwhelms the remaining aspects of the site. Nevertheless, it is a joyful park full of people playing with children, giddy

Figure 100. Plum blossoms viewed through a blossom-shaped window.

friends riding in boats, lovers nestled together in the corners of pavilions, and gardeners pruning deadwood and sweeping the water with nets.

PAUSE AND OBSERVE: BLOSSOMS

A small grove of plum trees is wrapped by a winding corridor with windows, couplets, and carved details that all reference the spring blossoms. Similar motifs abound in all the gardens with peach, pear, magnolia, quince, pomegranate, crabapple, and loquat blossom patterns cut into windows

and doorways, embedded in mosaic pavements, poetically alluded to in elegant calligraphy, or painted in muted shades on large silk scrolls.

The orchard, as mentioned earlier, is an enduring symbol of a harmonious and peaceful utopia in Chinese literature. The presence of such orchards or specimen fruit trees represents both this ideal and the virtues of agricultural production.

ADDRESS

上海市嘉定区南翔镇沪宜路 218 号, Huyi Road 218, Nanxiang Town, Jiading District, Shanghai

OTHER GARDENS IN
SUZHOU AND REGION

The following Suzhou gardens are not included in the expanded descriptions but visits may be made or arranged:

Five Peaks Garden, Wufeng Yuan
Kettle Garden, Hu Yuan
Listening to Maples Garden, Tingfeng Yuan
Northern Half Garden, Bei Ban Yuan
Remnant Grain Garden, Canli Yuan
Satisfying Garden, Ke Yuan
Suzhou Museum, Suzhou Bowuguan

The following gardens, parks, lakes, and residences would reward travel near Suzhou:

YANGZHOU

Ge Yuan
He Yuan
Xiaopan Gu
Shou Xihu

NANJING

Zhan Yuan

Xu Yuan
Xuanwu Hu

HANGZHOU

Guozhuang
Xiling Yinshe
Xihu

NINGBO

Tianyi Ge

CHANGZHOU

Jin Yuan

JIADING

Qiuxia Yuan

QINGPU

Qushui Yuan

NANXUN

Xiao Lianzhuang
Zhang Shiling Jiuzhai
Baijian Lou
Jiaye Tang Cangshu Lou

CHANGSHU

Yan Yuan

HAIYAN

Qi Yuan

SONGJIANG

Zui Baichi

MUDU

Xian Yuan
Gusong Yuan

TIANPING MOUNTAIN

Tianping Shanzhuang

TAIZHOU

Qian Yuan

RUGAO

Shuihui Yuan

Figure 107. Garden of the Suzhou Museum, Suzhou Bowuguan.

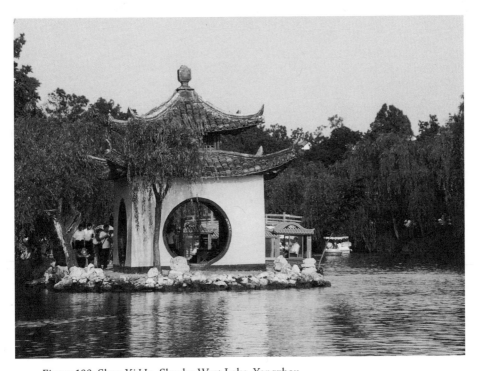

Figure 108. Shou Xi Hu, Slender West Lake, Yangzhou.

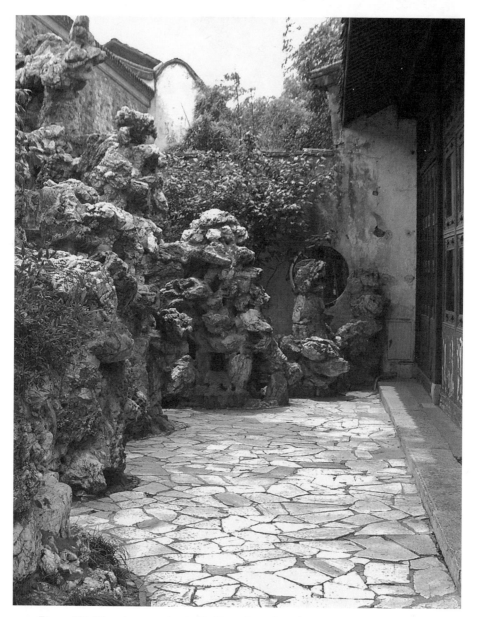

Figure 109. The winter garden in Ge Yuan, Yangzhou, has pavement with a cracked ice pattern.

COMPARATIVE PLANS

The following pages include plans of many of the gardens described in the preceding chapters. These plans provide a means of comparing similarities and differences among the buildings and water in the gardens.

BUILDINGS

Two building typologies are evident in almost all the Suzhou gardens. The first is the dense courtyard houses that constitute the residential quarters of the properties. In the comparative plans, these buildings appear as densely built quarters that occupy up to two-thirds of the property. The remaining property is allocated for the gardens which are populated by the second building typology—an array of halls and pavilions that drift through the gardens.

The residential buildings are strictly oriented in a southerly direction and thus lay out along south-to-north axes. In contrast, the garden buildings are variously inflected in their orientation to the water, to the rockeries, to garden courtyards, and often to external views or borrowed scenery. The result is a richly varied collection of halls and pavilions distributed in the gardens of Suzhou.

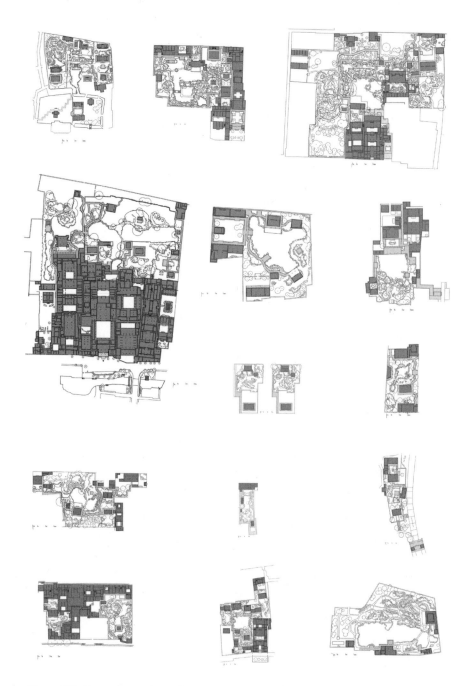

Figure 101. Comparative plans of the garden buildings

(left to right, top to bottom): Garden of Peace and Comfort, Lion Grove, Lingering Garden, Humble Administrator's Garden, Garden of Retreat and Reflection, Garden of Cultivation, Mountain Villa of Embracing Beauty, Crane Garden, Garden of Harmony, Zigzag Garden, Mountain Villa of Embracing Emerald, Couple's Garden, Master of the Nets Garden, and Garden of the Peaceful Mind

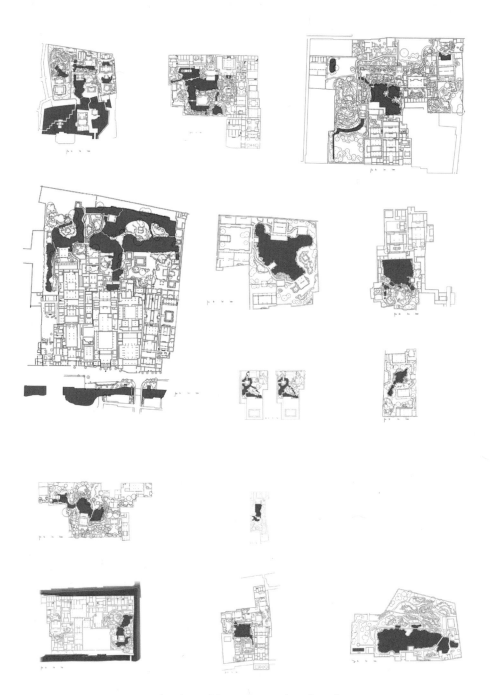

Figure 102. Comparative plans of the garden ponds and canals

(left to right, top to bottom): Garden of Peace and Comfort, Lion Grove, Lingering Garden, Humble Administrator's Garden, Garden of Retreat and Reflection, Garden of Cultivation, Mountain Villa of Embracing Beauty, Crane Garden, Garden of Harmony, Zigzag Garden, Couple's Garden, Master of the Nets Garden, and Garden of the Peaceful Mind

WATER

At the center of almost all the gardens is water. A striking exception to this is the Mountain Villa of Embracing Beauty where the rockery occupies the center. The shapes of the ponds follow two patterns more or less. The larger gardens, such as the Humble Administrator's Garden and the Garden of the Peaceful Mind, have elongated ponds that stretch across the garden. Smaller gardens, such as the Master of the Nets and the Garden of Retreat and Reflection, have compact (almost square) ponds at their center. Each of the water bodies has streams or channels that connect the larger pond to smaller waterways both within the garden and to the larger integrated water system that courses throughout the Suzhou region.

Several of the private gardens, such as the Humble Administrator's Garden, have islands in the ponds, although islands are more common in the imperial gardens where they are manifestations of the belief that immortals lived on islands in the sea off the eastern coast of Shandong Province. In accordance with this narrative, islands were commonly integrated into the gardens as sites for immortals.

PLANTS IN THE
GARDENS OF SUZHOU

HERBACEOUS GROUNDCOVERS

Liriope spicata / muscari, lilyturf
Ophiopogon japonicus, mondo grass

DECIDUOUS SHRUBS AND VINES

Camellia sinensis, tea
Chaenomeles spp., flowering quince
Jasminum polyanthum, climbing jasmine
Kerria japonica, kerria
Lonicera maackii, amur honeysuckle
Mahonia fortunei, Chinese mahonia
Nandina domestica, nandina
Peony suffruticosa, tree peony
Rosa multiflora, rambling rose
Wisteria sinensis, wisteria

BROADLEAF EVERGREEN SHRUBS

Rhododendron (subspecies *tsutsusi and pentanthera*), azalea
Ilex crenata, Japanese littleleaf holly
Osmanthus fragrans, fragrant tea olive
Podocarpus macrophyllus, bigleaf podocarp

CONIFEROUS (OR NEEDLE) EVERGREEN SHRUBS

Taxus chinensis, Chinese yew

SMALL DECIDUOUS TREES

Camellia japonica, camellia
Cercis chinensis, Chinese redbud
Lagerstroemia indica, crepe myrtle

FRUITING TREES

Diospyros kaki, Asian persimmon
Eriobotrya japonica, loquat
Malus spp., apple
Malus spectabilis, crabapple
Musa spp., banana
Prunus armeniaca, apricot
Prunus domestica, plum
Prunus mume, apricot
Prunus persica, peach
Punica granatum, pomegranate
Pyrus spp., pear

LARGE (CANOPY) DECIDUOUS TREES

Acer buergerianum, trident maple
Acer palmatum, Japanese maple
Cinnamomum camphora, camphor tree
Celtis sinensis, hackberry
Ginkgo biloba, ginkgo
Koelreuteria paniculata, golden raintree
Liquidambar formosana, sweetgum
Magnolia denudata, yulan magnolia
Magnolia grandiflora, southern magnolia
 (a North American species)
Magnolia liliiflora, mulan magnolia
Magnolia x soulangiana, saucer magnolia

Platanus x hispanica, planetree
Robinia pseudoacacia, black locust
Salix babylonica, weeping willow
Styphnolobium japonicum, sophora, scholartree

BROADLEAF EVERGREEN TREES

Ulmus parvifolia, lacebark elm

CONIFEROUS DECIDUOUS TREES

Metasequoia glyptostroboides, dawn redwood
Pseudolarix kaempferi, golden larch
Taxodium ascendens, pond cypress
Taxodium distichum, bald cypress

CONIFEROUS EVERGREEN TREES

Cedrus deodara, deodar cedar
Chamaecyparis obtusa, hinoki falsecypress
Cryptomeria fortunei, Chinese cedar
Juniperus chinesis, Chinese juniper
Pinus aspera, brocaded pine
Pinus bungeana, lacebark pine
Pinus densiflora, Japanese red pine
Pinus parviflora, Japanese white pine
Pinus pinaster, cluster pine
Pinus taiwanensis, Taiwan pine
Pinus thunbergii, Japanese black pine
Platycladus orientalis, oriental arborvitae

BAMBOO

Arundo spp.
Bambusa spp.
Chimonobambuca spp.
Indocalamus spp.
Phyllostachys spp.

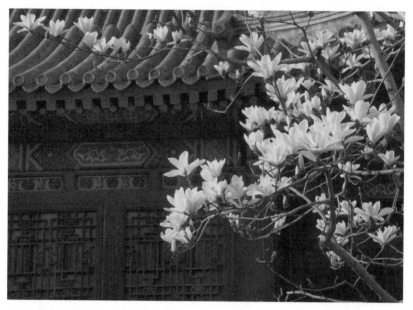

Figure 103. *Magnolia denudata*, called yulan in China, is often planted in the first courtyard of residences for its noble beauty and early spring fragrance. The second courtyard is commonly planted with a flowering fruit tree such as a pomegranate or pear that blooms later in the spring; the third courtyard with a deciduous tree, such as a maple, that exhibits vibrant fall foliage; and the fourth courtyard with an evergreen pine, symbolizing longevity.

AQUATICS

Cyperus papyrus, papyrus
Nelumbo spp., lotus
Nymphae spp., water lily
Pontederia spp,. pickerel

STONE IN THE
GARDENS OF SUZHOU

Stones are piled into rockeries and used as revetments along garden streams. Large specimen stones, such as the Cloud Capped Peak in the Lingering Garden, are prominently displayed in courtyards. Smaller specimen stones are carefully fitted to wooden trays for display on long, high tables—a stone version of penzai. Thinly sliced stones with veining that resembles paintings of mountains are hung on walls or sit in frames that stand on a scholar's desk.

This wide-ranging appreciation of stone was outlined in a third-century B.C.E. text in which "weird rocks," *guan shi*, are sent to the mythical emperor Yu. Two-thousand-year-old historical records include mention of stones being sent in tribute to China's emperors.

As Graham Parkes notes, "the Chinese veneration for stone in its natural, unworked state is unparalleled in its intensity and range. . . . At first a prerogative of the imperial families, enthusiasm for stone spread subsequently to the literati, and it remains widespread in the culture to this day."

Figure 104. Pavements are often comprised of small pieces of gray granite, softly rounded river stones, and thin ceramic roofing tiles.

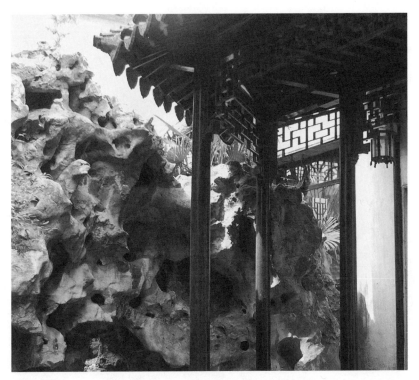

Figure 105. Tai Lake limestone is porous, craggy, and grayish-white.

Figure 106. Tall, thin, green jadestones are often exhibited in bamboo groves.

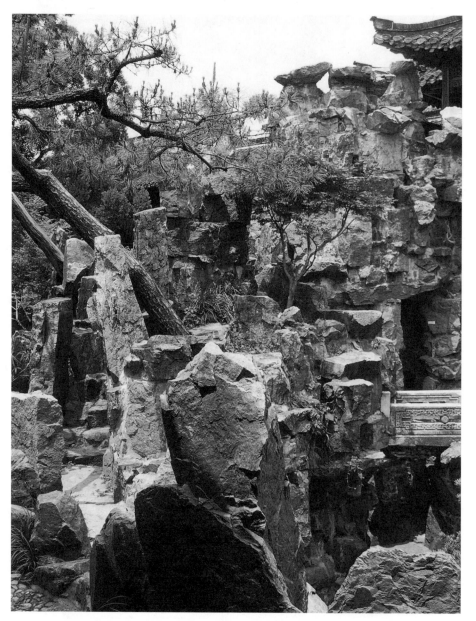

Figure 107. Huangshan yellow stone is cubic, angular, and orange-yellow—often with veins of purple.

GLOSSARY

GARDENS

bu yi jing yi: walking through changing scenery

jiejin: borrowed scenery

lang: corridor

loujing: view garden through a carved window

men: gate, as in Tiannanmen, the heavenly (tian) south (nan) gate (men)

penjing / penzai: potted landscape / bonsai

qiang: wall

qiao: bridge

siheyuan: courtyard garden, literally four (si) sided (he) garden (yuan)

tang: hall

ting: pavilion

yuan: garden

ELEMENTS

feng: wind

hai: sea

he: river

hu: lake

hua: flower

shan: mountain

shi: stone

shu: tree

shui: water

DIRECTIONS AND MEASUREMENT

bei: north (as in Beijing, the north capital)

dong: east (as in Shandong Province, east mountains)

nan: south (as in Nanjing, the south capital)

xi: west (as in Xihu, West Lake)

mu: traditional measurement of area, approximately 7,176 square feet

SUGGESTED READINGS

Cao Xueqin. *The Story of the Stone*, or *The Dream of the Red Chamber*, c. 1760, translation by David Hawkes and John Minford. Bloomington: Indiana University Press, 1979.

Chen Congzhou. *On Chinese Gardens*. Shanghai: Tongji University Press, 1984.

Chen Lifang and Sianglin Yu. *The Garden Art of China*. Portland: Timber Press, 1986

The Classical Gardens of Suzhou. Beijing: China Intercontinental Press, 2004.

Clunas, Craig, *Fruitful Sites: Garden Culture in Ming Dynasty Culture*. Durham: Duke University Press, 1996

Doar, Bruce Gordon, "Acquiring Gardens," *China Heritage Quarterly* 9, (March 2007).

Elvin, Mark. *Retreat of the Elephant: An Environmental History of China*. New Haven: Yale University Press, 2004.

Fung, Stanislaus. "Here and There in Yuan Ye." *Studies in the History of Gardens and Designed Landscapes* 19, no. 1 (Spring 1999) *Proceedings of the Immediate Garden & The Larger Landscape Symposium, Isabella Stewart Gardner Museum, 15 March 1997*

Guo Xi, "Lofty Record of Forests and Streams" (Lin quan gao zhi).

Harrison, Robert Pogue, *Gardens: An Essay on the Human Condition*. Chicago: University of Chicago Press, 2008

Inn, Henry and S. C. Lee. *Chinese Houses and Gardens*. New York: Bonanza Books, 1940.

Ji Cheng. *The Craft of Gardens.* Translated by Alison Hardie. 2nd edition. Shanghai: Shanghai Press and Publishing Development Company, 2012.

Johnston, R. Stewart. *Scholar Gardens of China: A Study and Analysis of the Spatial Design of the Chinese Private Garden.* Cambridge: Cambridge University Press, 1991.

Keswick, Maggie. *The Chinese Garden: History, Art and Architecture.* 3rd edition. Cambridge, Mass.: Harvard University Press, 2003.

Liu, Dunzhen, *Chinese Classical Gardens of Suzhou.* New York: McGraw-Hill, 1993.

Lou, Qingxi. *Chinese Gardens.* Beijing: China Intercontinental Press, 2003.

Morris, Edwin. *The Gardens of China: History, Art, and Meanings.* New York: Scribner's, 1983.

Morris, Jan. "A Scholar's Garden in Ming China: Dream and Reality." *Asian Art* 3, no. 4 (Fall 1990): 31–51.

Parkes, Graham. "Thinking Rocks, Living Stones: Reflections on Chinese Lithophilia." *Diogenes* 52, no. 3 (2005), 75–87.

Peng, Yigang. *Analysis of the Traditional Chinese Garden.* 15th edition. Beijing: China Architecture & Building Press, 2003 (in Chinese).

Qian, Yun, Lu Yuan Conghua (Miscellaneous Remarks on Lu Garden) Vol. 12.

Ryckmans, Pierre. "The Chinese Attitude Towards the Past." *China Heritage Quarterly* 14, (June 2008).

Schwarcz, Vera. *Place and Memory in the Singing Crane Garden.* Philadelphia: University of Pennsylvania Press, 2008.

Sickman, Laurence, and Alexander Soper. *The Art and Architecture of China.* London: Penguin Books, 1971.

Siren, Osvald. *China and Gardens of Europe of the Eighteenth Century.* Washington, D.C.: Dumbarton Oaks, 1990.

Steinhardt, Nancy Shatzman. *Chinese Imperial City Planning.* Honolulu: University of Hawaii Press, 1990.

Studies in the History of Gardens & Designed Landscapes, guest edited by Stanislaus Fung and John Makeham in honor of Professor Chen Congzhou of Shanghai, 18, no. 3 (July–September 1998).

Studies in the History of Gardens & Designed Landscapes, guest edited by Stanislaus Fung in memory of Professor Chen Zhi (1899–1989) of Nanjing, 19, nos. 3–4 (July–December 1999).

Titley, Norah, and Frances Wood. *Oriental Gardens: An Illustrated History*. San Francisco: Chronicle Books, 1991.

Treib, Marc, and Ron Herman. *A Guide to the Gardens of Kyoto*. Tokyo: Shufunotomo, 1980; revised edition, 2003.

Valder, Peter. *The Garden Plants of China*. Portland: Timber Press, 1999.

INDEX

bamboo, 101, 107, 109, 115, 140, 142, 158, *fig. 106*

Bei Ban Yuan. *See* Northern Half Garden

Bei Ieoh Ming (I. M. Pei), 55

Beijing, 9

Bei Runsheng, 55

Bi Yuan, 96

Bishu Shanzhuang. *See* Mountain Resort in Chengde

Book of Songs, 3

borrowed scenery, 38, 124, 128, *figs. 23, 89*

bridges; Fish Viewing Bridge, 93; Heavenly Bridge, 120; Nine-Zigzag Bridge, 141; Small Flying Rainbow Bridge, 39; Surging Waves Bridge, 100, 106; zigzag, 121, 130, *fig. 22*

Buddhism, 10, 18

camphor (*Cinnamomum camphora*), 57, 109, *fig. 37*

Canglang Ting. *See* Surging Wave Pavilion

Canli Yuan. *See* Remnant Grain Garden

Cao Xueqin, 16, 111

Carefree Garden, Chang Yuan, 10, 113-116, *figs. 80, 81, 82*

Chang Yuan. *See* Carefree Garden

Changshu; Yan Yuan, 95, 150

Changzhou; Jin Yuan, 150

Chen Congzhou, 14, 121

Clunas, Craig, 7

Confucian, 21, 23

corridor, 39, 43, 45-47, 57, 60, 71, 114, 115, *fig. 24, 29, 82*; corridor, double, 60, 63, 77, *figs. 40, 54, 55*

Couple's Garden, Ou Yuan, 81-87, *figs. 56, 57, 58, 59, 101*

couplet, *fig. 59*

Craft of Gardens, The, Yuan Ye, 16, 123

Crane Garden, He Yuan, 10, 108-110, *figs. 76, 77, 101*

Cultural Revolution, 67, 110

Daoism, 3, 7, 21, 110

Dream of Red Mansions, The. See Story of the Stone

Dynasty/Period (chronological); Spring and Autumn Period (771 BCE-475 BCE), 7; Han—Eastern, Western, Xin (206 BCE-220 CE), 8; Jin—Eastern, Western (265-420), 102; Tang (618-907), 12, 143; Song—Northern and Southern (900-1279), 9, 12, 119, 137; Yuan (1271-1368), 10, 12, 18, 124; Ming (1368-1644), 7, 9, 10, 13, 16, 25, 123, 124, 130, 133, 140, 142; Qing (1644-1911),

Dynasty/Period (*continued*)
9, 10, 13, 16, 94, 107, 110, 111, 119,
121, 125

Elvin, Mark, 1
Emperors; Guangxu (Qing, ruled
1875-1908), 108; Daoguang (Qing,
ruled 1820-1850), 97; Jiajing
(Ming, ruled 1521-1567), 130;
Kangxi (Qing, ruled 1661-1722),
62, 63, 125; Qianlong (Qing, ruled
1735-1796), 15, 53, 66, 94, 96, 125,
126; Qingli (a named period of rule
by Renzong) (Song, 1041-49), 9;
Xuantong (Qing, ruled 1908-1911),
108; Zhengde (Ming, ruled
1505-1521), 35

feng shui, 45, 121
Five Peaks Garden, Wufeng Yuan, 149
flying eave *fig. 15*
Forbidden City, 5, 21
Former Residence of Yu Yu. *See* Zigzag
Garden
Fu Chai, 8

Garden of Ancient Splendor, Guyi Yuan,
10, 139, 140-146, *figs. 96, 97, 98,
99, 100*
Garden of Cultivation, Yi Pu, 10, 25,
88-94, *figs. 60, 61, 62, 63, 64, 101*
Garden of Retreat and Reflection, Tuisi
Yuan, 10, 119-123, 146, *figs. 83, 84,
101*
Garden of Harmonious Interests, Xiequ
Yuan, 125
Garden of Harmony, Yi Yuan, 10, 14,
78-80, *figs. 53, 54, 55, 101*
Garden of Peace and Comfort, Yu Yuan,
10, 130-139, *figs. 90, 91, 92, 93, 94,
95, 101*
Garden of the Peaceful Mind, Jichang
Yuan, 10, 15, 124-129, 146, *figs. 86,
87, 88, 89, 101*
Garden of Perfect Brightness, Yuanming
Yuan, 5, 6, 53, *fig. 4*

Ge Yuliang, 16, 94, 95
Gesu Terrace, 8
ginkgo (*Ginkgo biloba*), 44, 45, 57
Grand Canal, 9, 123
Guanwa Palace, 8
Guan-yun. *See* Cloud-Crowned Peak
Guo Xi, 65
Guyi Yuan. *See* Garden of Ancient
Splendor

Haiyan; Qi Yuan, 150
Halls; Broken Beam Hall, 106; Carrying
Wine Hall, 82; Celestial Hall of
Five Peaks, 44; Enlightenment Hall,
61, 64; Five Peaks Library, 71; Hall
for Remembering Ancestors, 90;
Hall of Distant Fragrance, 38, *fig.
16*; Hall of Erudition and Elegance,
90; Hall of Five Hundred Sages,
61; Hall of Harmony, 69; Hall of
Supreme Harmony, 21; Hall of
Ten Thousand Volumes, 21, 65,
67, 68; Holding the Jar Hall, 100;
Housing the Mountain with a Half-
filled Pool in Autumn Hall, 96, 97;
Looking at Cypress Hall, 56; Lute
Chamber, 69; Meditation Study,
71; Nanmu Hall (Garden of Peace
and Comfort), 137; Nanmu Hall
(Lingering Garden), 21, 48; Nanmu
Hall (Mountain Resort in Chengde),
23; Old Hermit Scholars House, 50;
Plum Blossom Hall, 143; Prospect
Hall, 28, 29; Scholars Retreat
Among the Clouds, 101; Small Hill
and Osmanthus Hall, 47, 67, 74,
figs. 47, 50, 51, 52; South Hall, 141,
142; The Thatched Hall of Retreat
and Reflection, 120; Thirty-Six
Pairs of Mandarin Ducks Hall, 39;
Three Ears of Corn Hall, 131; Wang
Ancestral Hall, 97
Hangzhou, 9; Guozhuang Villa, 121,
150; Xihu, West Lake, 150; Xiling
Yinshe, 150
Harrison, Robert Pogue, 5

He Cheng, 67
He Lu, 7, 8
He Yuan, Suzhou. *See* Crane Garden
Hong Luting, 108
Hu Yuan. *See* Kettle Garden
Huangpu River, 133
Huanxiu Shanzhuang. *See* Mountain
 Villa of Embracing Beauty
Huishan, 124, 128
Humble Administrator's Garden,
 Zhuozheng Yuan, 10, 16, 20, 25,
 33-42, 57, 88, 111, 128, 146, *figs. 10,
 16, 19, 20, 21, 22, 23, 24, 25, 26, 101*

Inner Garden. *See* Garden of Peace and
 Comfort

Jacobs, Peter, 14
jadestones, *fig. 106*
Jiading; Qiuxia Yuan, 150
Jiang Ji, 96
Jiang Kui, 119
Ji Cheng, 16, 123
Jichang Yuan. *See* Garden of the Peaceful
 Mind

Kamakura, 16
Kang Sheng, 67
Katsura Rikyu, 20, *fig. 11*
Keswick, Maggie, 43, 130
Kettle Garden, Hu Yuan, 149
Ke Yuan. *See* Satisfying Garden
Kublai Khan, 10, 12
Kyoto, 20

Laozi, 110
Li Hongyi, 67
Lingering Garden, Liu Yuan, 10, 43-50,
 57, 128, *fig. 9, 27, 28, 29, 30, 31, 32,
 33, 34, 101*
Lion Grove, Shizilin, 10, 16, 51, 53-59,
 124, 128, *figs. 18, 35, 36, 37, 38, 101*
Listening to Maples Garden, Tingfeng
 Yuan, 149
Liu Dunzhen, *fig. 50*
Liu Yuan. *See* Lingering Garden

*Lu Yuan Conghua. See Miscellaneous
 Remarks on Lu Garden*

magnolia; southern (*Magnolia
 grandiflora*), 114, *fig. 80*; yulan
 (*Magnolia denudata*), *fig. 102*
Manual of the Mustard Seed Garden,
 16
maple (*Acer palmatum*), 44
Master of the Nets Garden, Wangshi
 Yuan, 14, 22, 23, 65-76, 121, 146,
 *figs. 12, 13, 42, 43, 44, 45, 46, 47, 48,
 49, 50, 51, 52, 101*
*Miscellaneous Remarks on Lu Garden,
 Lu Yuan Conghu*, 94
moon gate, 91, *figs. 21, 60, 63*
Mountain Resort in Chengde, Bishu
 Shanzhuang, 2, 5 *fig. 24*
Mountain Villa of Embracing Beauty,
 Huanxiu Shanzhuang, 10, 16,
 95-100, 128, 146, *figs. 66, 67, 68,
 69, 101*
Mountain Villa of Embracing Emerald,
 Yongcui Shanzhuang, 10, 101-107,
 figs. 70, 71, 72, 73, 74, 75, 101
Mudu: Gusong Yuan, 150; Xian Yuan,
 150
Muso Soseki, 18, *fig. 8*

Nanjing; Xu Yuan, 150; Xuanwu Hu,
 150; Zhan Yuan, 150
nanmu (*Phoebe nanmu*), 48, 137
Nanxiang, 139; Guyi Yuan (*see* Garden
 of Ancient Splendor); *xiaolongbao*
 (dumplings), 139, 140
Nanxun: Baijian Lou, 150; Jiaye
 Tang Cangshu Lou, 150; Xiao
 Lianzhuang, 150; Zhang Shiling
 Jiuzhai, 150
Nei Yuan. *See* Garden of Peace and
 Comfort, Inner Garden
Ningbo; Tianyi Ge, 150
Northern Half Garden, Bei Ban Yuan,
 149

Ou Yuan. *See* Couple's Garden

Pacific Ocean, 2
pagoda: Cloud Crag Pagoda, 103, *fig. 75*;
 North Pagoda, 38, 128, *fig. 23*; Pearl
 Pagoda, 123
Pan En, 130
Pan Gate, Panmen, 8
Pan Yue, 35
Pan Yunduan, 130, 137
pavement, 36, 146, *fig. 105*
pavilions: Among Mountains and Water
 Pavilion, 82; Convex Pavilion, 27;
 Crane and Longevity Pavilion, 84;
 Fish Breeding Pavilion, 64, *fig. 64*;
 Floating Bamboo Pavilion, 142;
 Gathering Beauty Pavilion, 121,
 fig. 84; Late Spring Cottage, 71;
 Longevity Pavilion, 89, 90; Lying
 in Clouds Pavilion, 56; Making Up
 Autumn Gallery, 97; Moon and
 Breeze Pavilion, 71; Old House
 with Woven Curtains, 84; Putting
 a Question to the Spring Pavilion,
 97; Refreshing Breeze Pavilion
 figs. 32, 33; Replenishing Autumn
 Landboat, 97; Sun and Moon
 Viewing Pavilion, 82; Sweet Grass
 House, 91; Viewing Hawks and Fish
 Pavilion, 141; Waiting for the Moon
 Pavilion, 113; Washing My Dusty
 Clothes Pavilion, 113; Washing
 My Tassels in the Water Pavilion,
 67, 71; Watching Pines Pavilion,
 71; Waterside Pavilion for Viewing
 Happy Fish, 133
penjing, 39, 44, 136
penzai. *See* penjing
pine, lacebark (*Pinus bungeana*), 48, 57,
 109
ponds: Free Captive Animals Pond,
 Fengsheng, 51; Rosy Clouds Pool,
 69
Prospect Garden, 111

qi, 52
Qian Yun, 94
Qin Liang, 124

Qingpu: Qushui Yuan, 150
Qu Yuan. *See* Zigzag Garden
Qu Yuancun, 67

Records on the Land of Peach Blossoms,
 7
Remnant Grain Garden, Canli Yuan,
 149
Ren Lansheng, 119
rockery, 94, 98, 99, 108, 113, 126, 130,
 135, *figs. 67, 69*
Rugao: Shuihui Yuan, 150
Ryckmans, Pierre, 15
Ryoan-ji, 17

Satisfying Garden, Ke Yuan, 149
Shandong Province, 1, 146
Shanghai; Yu Yuan. *See* Garden of Peace
 and Comfort
Shen Shixing, 96
Shen Zhou, 42, *fig. 6*
Shi Zhengshi, 10, 65, 66, 71
Shinohara Kazuo, 18
Shizilin. *See* Lion Grove
Silk Road, 8
Song Zongyuan, 66
Songjiang; Zui Baichi, 150
Songs of Chu, 3, 60
stones; Auspicious Cloud, Rui-yun, 51;
 Caved Cloud, Xiu-yun, 51; Cloud-
 Capped Peak, Guan-yun, 43, 51,
 fig. 34; Exquisite Jade Peak, 137
Story of the Stone, The, 16, 20, 28, 60, 84,
 110
Su Shi, 25
Summer Palace, Yihe Yuan, 5, 126
Sun Guyuan, 94
Sun Shiyi, 96
Sun Shunqing, 9, 63
Surging Wave Pavilion, Canglang Ting,
 9, 60-64, *figs. 5, 39, 40, 41*
Surging Wave Pavilion, Small (Humble
 Administrator's Garden), 39
Suzhou Bowuguan. *See* Suzhou Museum
Suzhou Museum, Suzhou Bowuguan, 12,
 149, *fig. 107*

Tai Lake, Tai Hu: lake, 2, 138; specimen stone and rockery, 43, 48, 50, 51, 94, 120, *fig. 62, 103*

Taiping Rebellion, 9, 10, 67, 128, 130, 136

Taizhou: Qian Yuan, 150

Tale of Genji, 20

Tanzhe Temple, 4, *fig. 3*

Tao Yuanming, 7

Tianping Mountain: Tianping Shanzhuang, 150

Tianru Weize, 53

Tiger Hill, 50, 100, 102-4, 128

Tingfeng Yuan. *See* Listening to Maples Garden

Tongli, 16, 119, 123; Tuisi Yuan. *See* Garden of Retreat and Reflection

Towers; Beauty Within Reach Tower, 68; Library Tower, 84; Sun and Moon Tower, 82; View Gathering Tower, 137; Watching for Scullers Tower, 82; West Tower, 23; Winding Creek Tower, 47

Tuisi Yuan. *See* Garden of Retreat and Reflection

Wang Wei, 57, *fig. 7*

Wang Xiachen, 33, 42

Wang Xishi, 124

Wang Garden, *fig. 17*

Wangshi Yuan. *See* Master of the Nets Garden

well, 26, *fig. 17*

Wen Zhengming, 33, 35, 42, 88, *figs. 25, 26*

Wen Zhenmeng, 88, 89

West Garden (Temple), Xi Yuan, 51-52

windows, carved, 23, 47, *fig. 30*

wisteria (*Wisteria sinensis*), 45, *fig. 20*

Wu School (of painting), 40

Wufeng Yuan. *See* Five Peaks Garden

Wuxi, 124, 129; Ji Chang Yuan. *See* Garden of the Peaceful Mind

Xi'an, 8

Xi Yuan. *See* West Garden

Xiequ Yuan. *See* Garden of Harmonious Interests

Xishan, 124

Xu Taishi, 50, 51

Yangtze River, 1, 2, 3, 9

Yangzhou, 9, *fig. 17*; Ge Yuan, 150, *fig. 106, 109*; He Yuan, Yangzhou, 150; Shou Xihu, Slender West Lake, 150, *fig. 108*; Xiaopan Gu, 95, 150

Yan Yonghua, 82, 84, *fig. 59*

yellow stone, 130, 133, *fig. 104*

Yi Pu. *See* Garden of Cultivation

Yi Yuan. *See* Garden of Harmony

Yihe Yuan. *See* Summer Palace

Yongcui Shanzhuang. *See* Mountain Villa of Embracing Emerald

Yu Pingbo, 110, 111

Yu Yuan. *See* Garden of Peace and Comfort

Yu Yue, 110

Yu Yue Gu Ju. *See* Zigzag Garden

Yuan Ye. See The Craft of Gardens

Yuanming Yuan. *See* Garden of Perfect Brightness

Zhang Daqian, 14, 67

Zhang Nanyang, 83, 130

Zhang Shanzi, 14

Zhejiang Province, 1

Zhongfeng, 10, 53

Zhou Bingzhou, 47

Zhouzhuang, 123

Zhu Shansong, 140

Zhuozheng Yuan. *See* The Humble Administrator's Garden

Zigzag Garden, Qu Yuan, 10, 111-112, *figs. 79, 101*

Zuisenji, 18, *fig. 8*

Zuo Rong, 8

Zuo's Garden, 8

Zuozhuan, 119

ACKNOWLEDGMENTS

Phoebe Hsu introduced me to the traditions of China and accompanied me on my first visit to the gardens of Suzhou. Laurie Olin—teacher, colleague, and friend (in no particular order)—encouraged, cajoled, and celebrated my effort. Anne Hawley cultivates her garden and, in the process, cultivates those around her.

My colleagues at Tsinghua University; Yang Rui, Hu Jie, Zhu Yufan, Zhang Jie, Zhang Li, Zhu Wenyi, and the students of the first classes of Tsinghua's Department of Landscape Architecture taught me much about the gardens. He Rui always responded to my requests for help with a gracious "my pleasure." My friends Tony Atkin, Will Hayes, and Stewart Mardeusz from the University of Pennsylvania invited me to accompany their studio and we endured bitter cold days in the gardens together. Ed Chang sent me far and wide to see these and other gardens. Jia Jun and Gu Kai added their knowledge to this project.

A Guide to the Gardens of Kyoto by Marc Treib and Ron Herman served as a model for my book, and I thank them for leading me through those gardens with their book in my pocket. Jo Joslyn, Caroline Winschel, and Noreen O'Connor-Abel at Penn Press guided the book project with gentle insistence and great care. Last, Peter Jacobs and John Dixon Hunt offered sage advice and guidance as did unknown readers who clarified my drifting thoughts of confounding gardens.

This book is dedicated to Mom, Dad, Johnny, and Kate.

RRLS